where to get married

SAN FRANCISCO BAY AREA

where to get married

married

SAN FRANCISCO BAY AREA

A Photographic Guide to the 100 Best Sites

by Reena Jana

photographs by Philippe Glade

CHRONICLE BOOKS

SAN FRANCISCO

Printed in Hong Kong.

Library of Congress Cataloging-in-Publication Data available.

ISBN 0-8118-2079-3

Design: Anne Culbertson

Distributed in Canada by
Raincoast Books
8680 Cambie Street
Vancouver, B.C. V6P 6M9

10 9 8 7 6 5 4 3 2 1

Chronicle Books
85 Second Street
San Francisco, CA 94105

www.chroniclebooks.com

To my parents, who have one of the most romantic marriages in history.

Contents

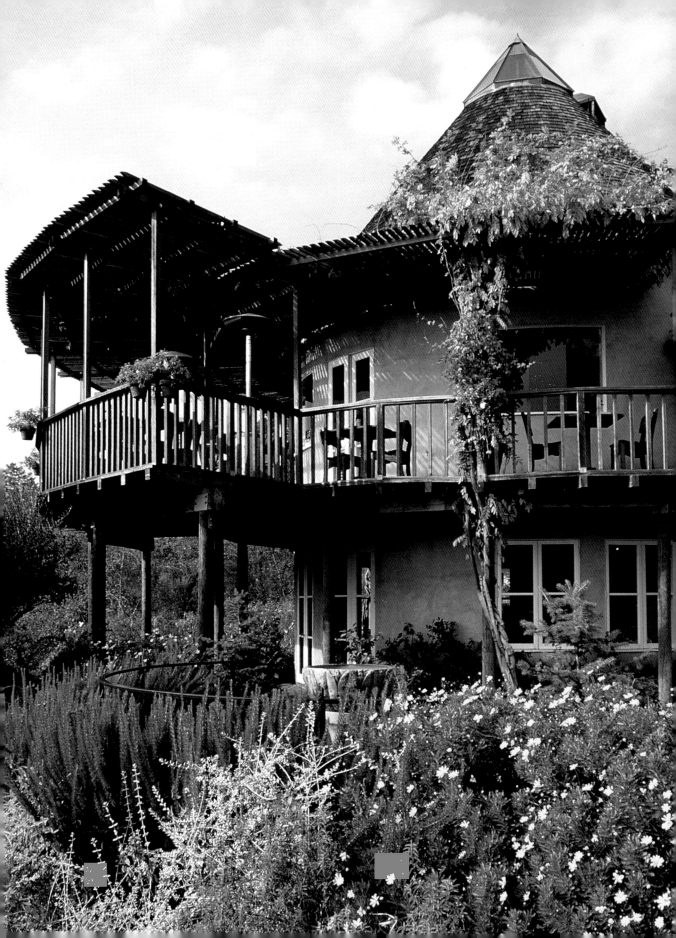

Introduction

The Beauty of a Bay Area Wedding

The title sequence for one of the San Francisco Bay Area's most popular news programs proudly proclaims this region "the best place on earth," and I couldn't agree more. With its breathtaking hills, mystical fog, majestic redwoods, azure ocean, verdant vineyards, graceful palms, and spectacular architecture, it's no wonder that this corner of the world inspires rhapsodic descriptions from anyone lucky enough to spend time here.

The Bay Area is such a great venue for unforgettable wedding celebrations because it has a grand sense of tradition and elegance, as well as great natural beauty. Both to its residents and to visitors from around the world, the Bay Area has an unparalleled atmosphere. Significant events in American history have taken place here, from the arrival of the Spanish and the pioneers to the gold rush, the Beat movement, the Summer of Love, and the Silicon Valley boom. This area is renowned for its architecture, from the area's "painted lady" Victorians and Arts and Crafts structures to its palatial estates and museums. When you consider what brides and grooms generally desire in a wedding location, it's clear that the Bay Area provides the sites for a great and true romance. This region has places that capture the essence of a couple's individual and combined personalities and tastes, providing comfort and welcome ambience in settings where they can begin to write the first lines of their history together.

This book was written with such ideals in mind, and with a focus on the unique charms of each part of the Bay Area—San Francisco, the East Bay, the North Bay, the Wine Country, the Peninsula, and the South Bay. Use this as a one-of-a-kind guide to wedding settings that exemplify the simultaneous sophistication and warmth of this section of the United States.

Additionally, the Bay Area is a popular destination for business conferences, meetings, and parties, and so it has a number of excellent, professional special events facilities that can also be great for weddings. The problem in the Bay Area is not in finding a wedding site, but in deciding on one among the wealth of choices.

Coincidentally, I wrote this book at the same time that I was engaged in the happy quest of finding my own Bay Area wedding site. Let this be real-life testimony that the Bay Area is a perfect setting for a wedding and trust that I drew on my experience not only as a cultural reporter and art critic—but as a bride-to-be as well.

What Makes These 100 Sites Special

Featured within this book are places that exemplify the Bay Area's legendary scenic beauty, hospitality, sophistication, creativity, and diversity—as well as its singular blend of refinement and informality. You'll find significant regional work by the Bay Area's own architecture and design icons, Bernard Maybeck and Julia Morgan; some famous estates; and vineyards and wineries. Also included are ships and waterfront venues, places of worship, the grandest of hotels, the most soothing of spa resorts, and private clubs. I've listed restaurants that serve the Bay Area's outstanding gourmet cuisine, national parks, gardens, museums, and more. For any budget and for style sensibilities ranging from the most traditional to the most chic to the most casual, the Bay Area lends an unparalleled flair to a wedding.

How to Use This Book

What makes a wedding location perfect? The answer is always different, depending on the bride and groom. Remember, the site you choose sets the stage forever. It's not merely a backdrop—it's a costar.

With this in mind, the following descriptions cover a range of diverse and enchanting locales for ceremonies and receptions. They are a peek into the Bay Area's most distinctive outdoor and indoor sites for weddings.

There's more than beauty involved in an ideal wedding spot, however; there's also the practical. Capacity, availability, amenities, convenience, and accessibility all play a role. As you consider which site best exemplifies you and your union, also make sure the setting accommodates the number of friends and family you wish to invite (figures are included in the text) and discuss how catering will be handled. Many sites offer in-house catering, or they supply lists of recommended or preferred caterers. The entry's location and contact information notes if these amenities are provided by a venue. If the introductory information does not mention in-house catering, you can assume that the site requires the wedding party to supply all catering.

Also included with the introductory information for each site is a general reference to rental fees, based on 1998 costs. Bear in mind that the categories used (Very Affordable, Moderate, and Deluxe) refer only to the costs of site rental and are in no way a "judgment" of the physical attractiveness of the site. "Very Affordable" means the rental or base fees are below $1,000; "Moderate" means the rental fees range between approximately $1,000 and $2,900; "Deluxe" means rental fees are above $2,900. Some sites in the "Deluxe" range might offer economical packages as well, and some venues labeled "Very Affordable" can provide as much elegance as those with a higher fee. All sites in the book are willing to tailor an event to your needs, and added costs, such as food and drink, vary widely depending on what you request. For these reasons, the cost ratings only apply to the foundation of the fees, which is site rental.

Planning a wedding involves choosing a particular season and time of day, and descriptions in this book include any restrictions on availability. Unless otherwise noted, facilities are generally available year-round. Remember the following commonsense guidelines for choosing a site when "when?" is a pressing factor. Facilities that also serve the public—restaurants, museums, clubs, and schools—usually have specific times in which ceremonies and receptions can occur. Outdoor venues throughout the Bay Area are generally warmest and will feature fully blooming gardens between the months of April through October (other months are prone to fog, rain, or chilliness). Also note that "summer" in San Francisco proper, in terms of temperature and sunshine, is usually late August, September, and October; the months that are considered prime "summertime" elsewhere in the nation—June and July—tend to be cool and foggy.

If your wedding site must be wheelchair-accessible, please check the site's introductory information for this feature. If wheelchair access is not mentioned, it is not available, at least at the time of this writing.

Remember, rental fees change, generally in the direction of an increase. Site names, amenities, and restrictions also may change. After you've found the locations that meet your desires, always be sure to call and get the most up-to-the-minute information. This book should only serve as your starting point.

Good luck in finding as wonderful a match in a location as you've found in a partner. And then, celebrate!

1409 Sutter Street

Angel Island

Archbishop's Mansion

California Palace of the Legion of Honor Cafe

The Carnelian Room

The City Club

Clift Hotel

Compass Rose Yachts

Fairmont Hotel

Ferryboat *Santa Rosa*

Flood Mansion

Forest Hill Clubhouse

Greens

Haas-Lilienthal House

Hamlin Mansion

Hornblower Dining Yachts

Limn Gallery

Main Post Chapel at the Presidio

The Majestic

The Marines' Memorial Club

Merchants Exchange Ballroom

Old Federal Reserve Bank Building

Palace of Fine Arts Rotunda

Queen Anne Hotel

Ritz-Carlton Hotel

Rose Garden

Sailing Ship *Dolph Rempp*

St. Gregory Nyssen Church

Shakespeare Garden

Sheraton Palace Hotel

Sir Francis Drake Hotel

Spectrum Gallery

Stern Grove

Swedenborgian Church

Temple Emanu-El

san francisco

1409 Sutter Street

San Francisco

415.561.0852

Moderate

In-house catering

Wheelchair accessible

Wealth from the legendary gold rush was often manifested in stately homes designed to impress guests, and this architectural gem is no exception. Listed in the National Register of Historic Places, 1409 Sutter was built in 1881 for Theodore P. Payne, who was lucky enough to strike it rich during the gold rush. Take your wedding guests back in time in this unusual building, a hybrid of the Eastlake, Stick, and Queen Anne Victorian styles. Shiny hardwood floors, stained-glass windows, and richly hued oak-paneled walls—plus two functional fireplaces in the Parlor and Red Room—add to the ambience of an earlier era.

Ceremonies generally take place in the Grand Hall, which has brass chandeliers and oriental rugs; this section of the mansion seats 63 to 90 (additional room for standing guests can be arranged). For larger parties, you can rent the entire main floor, which accommodates 120 seated or 250 standing guests. You can also rent portions or different combinations of rooms. The on-site event planner can arrange nearby garage parking, limousines, and shuttle buses, as well as entertainment, flowers, and music.

1409 Sutter Street

Angel Island

San Francisco Bay

510.426.3058

Very Affordable

Catering available

Wheelchair accessible,

except for chapel

When celebrating a wedding at this state park, guests arrive by ferry. Once on the island, they are met with unparalleled views of the San Francisco Bay and surrounding cities. This breathtaking natural setting has a rich historical past. In the 1800s, newly arrived Asian immigrants first had to pass through Angel Island. Weddings now take place in the forts and garrisons that originally housed the U.S. military. The Fort McDowell chapel offers tall, open-beamed ceilings, antique wooden pews, a choir loft, and seating for 200 guests. The East Garrison area near the chapel is a fabulous spot for an outdoor reception of up to 1,000 guests—and even features a cove where privately chartered boats can dock.

There's no shortage of scenic spots beyond these sites either. The Camp Reynolds area of the island on the waterfront accommodates up to 500 outdoor guests on its lawn. You can also ask about weddings above Ayala Cove, which looks out to Tiburon, or at the Battery Ledyard, which offers views of San Francisco and the Golden Gate Bridge.

Angel Island

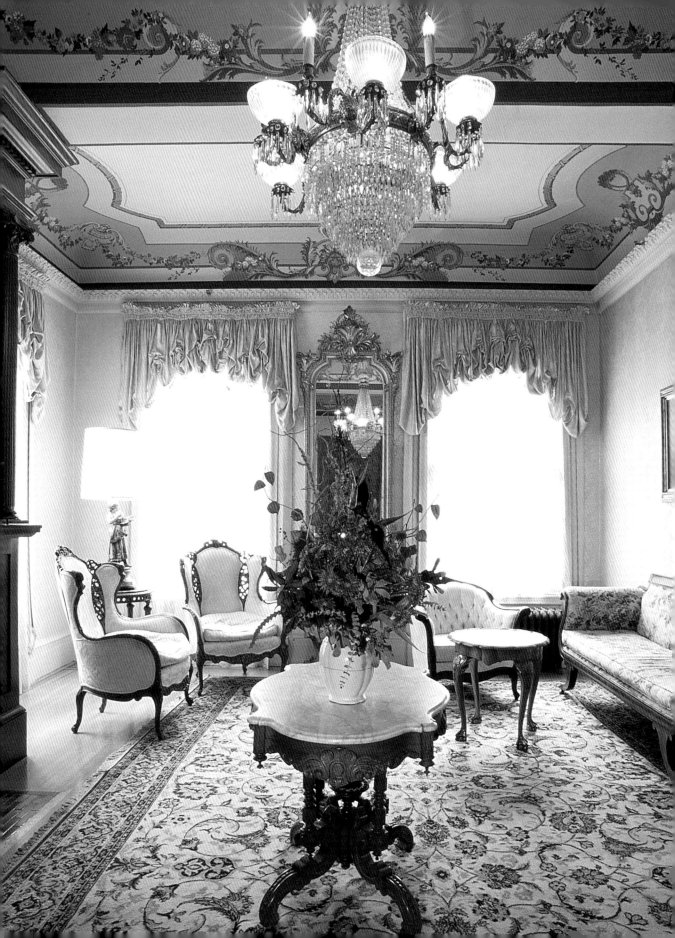

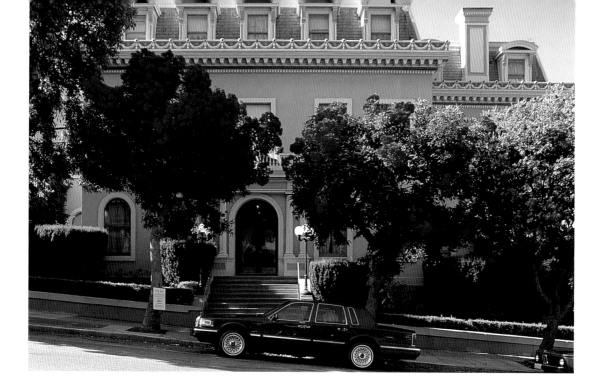

Archbishop's Mansion
1000 Fulton Street
San Francisco
415.563.7872, 800.543.5820
Very Affordable
Can arrange catering

Romance and history intertwine at this landmark bed-and-breakfast inn. Where else can you find a crystal chandelier from the set of *Gone with the Wind* hanging in a parlor near a full-length, gold-leaf framed mirror that once belonged to Mrs. Abe Lincoln?

This architectural beauty dates back to 1904, when it was built as a residence for the archbishop of San Francisco. Today, it is considered one of America's most stylish inns, thanks to the gorgeous redwood and mahogany woodwork, period furniture, and stunning stained-glass domed skylight. Imagine a bride descending a grand staircase as candles gleam in candelabras and sconces, to arrive in the Great Hall that serves as the mansion's foyer (accommodates 50 to 75 seated or standing guests).

Smaller ceremonies take place in the lovely Don Giovanni Salon, for 15 to 30 seated or standing guests. And what better place to cut the wedding cake than in the mansion's parlor, below the same chandelier under which Scarlet and Rhett kissed? The area surrounding the mansion is no less romantic and dramatic. Outside the front door is the picturesque Alamo Square, a park surrounded by some of San Francisco's finest examples of classic Victorian houses.

Archbishop's Mansion

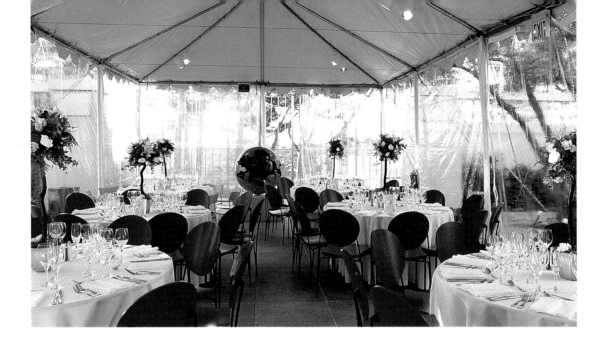

California Palace of the
Legion of Honor Cafe
Lincoln Park
Clement Street and
34th Avenue
San Francisco
415.221.2233
Moderate to Deluxe
In-house catering
Wheelchair accessible

The California Palace of the Legion of Honor, with its handsome archways and classic pillars inspired by France's elegant la Légion d'honneur, is an internationally acclaimed museum that houses a prized collection of world-class art, including a cast of Rodin's sculpture *The Thinker*. Its environs include nothing less than the Pacific Ocean as well as cypress trees and the sprawling lawns of the Presidio Golf Course.

A ceremony and reception in such an exquisite site can only be filled with beauty and grace. The Legion's cafe—the setting for weddings for up to 150 seated or 300 standing guests—offers giant windows and French doors for natural light to pour into the space. Adjacent is the outdoor terrace, complete with sculpture gardens and walkways, an area that accommodates 300 standing guests under a full tent, or 220 standing guests under a partial tent. This scene is awe-inspiring at night, when the majestic palace glows in the spotlights—a sight your guests will definitely witness because weddings occur only after 6 P.M. (once the museum is closed to the public). If your heart's set on a ceremony in the Legion of Honor itself, small weddings can be arranged, for a maximum of 80 guests, in the private Board Room with special permission.

California Palace of the Legion of Honor Cafe

The Carnelian Room
555 California Street
52nd Floor
San Francisco
415.433.7500
Moderate
In-house catering

Perched high above San Francisco, this site has a rare ambience that's both contemporary and Old World. Located in the Bank of America skyscraper, the Carnelian Room offers you and your guests a panoramic vista. You'll see both the Bay and Golden Gate Bridges, the hills of the East Bay, and the waterfront Embarcadero, all while enjoying a handsome interior adorned with beautiful paintings from the 1700s and 1800s mounted on walls paneled with deep, dark wood. The seasoned staff is ready to help you coordinate your wedding and can arrange such amenities as a dance floor or tailor-made menus.

There is a range of options for ceremony sites within the Carnelian Room. The smaller Belvedere Room accommodates 65 standing guests; the Board Room holds 100 seated or 200 standing guests; the Pacific Room can accommodate 110 seated or 185 standing guests. You can also choose a combination of all three. For a more cosmopolitan reception, the Main Dining Room, which has an impressively extensive wine list, can be configured to accommodate any number of guests up to a maximum of 500.

The Carnelian Room

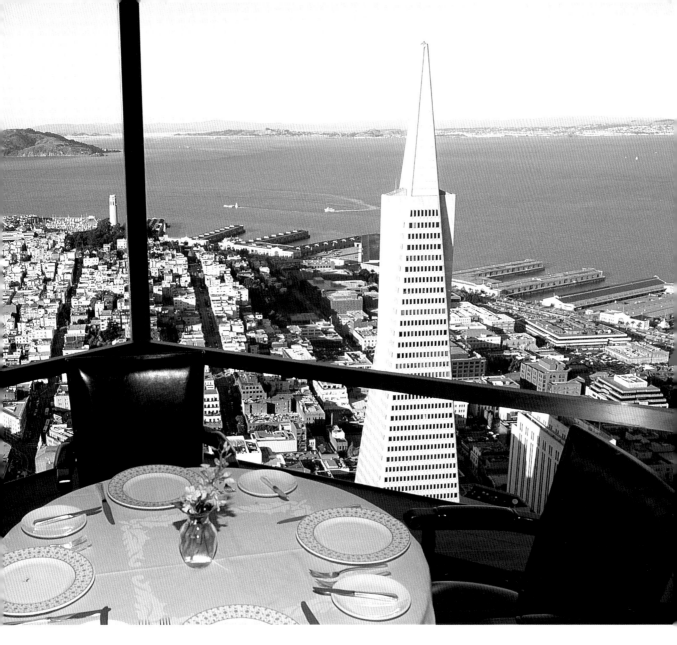

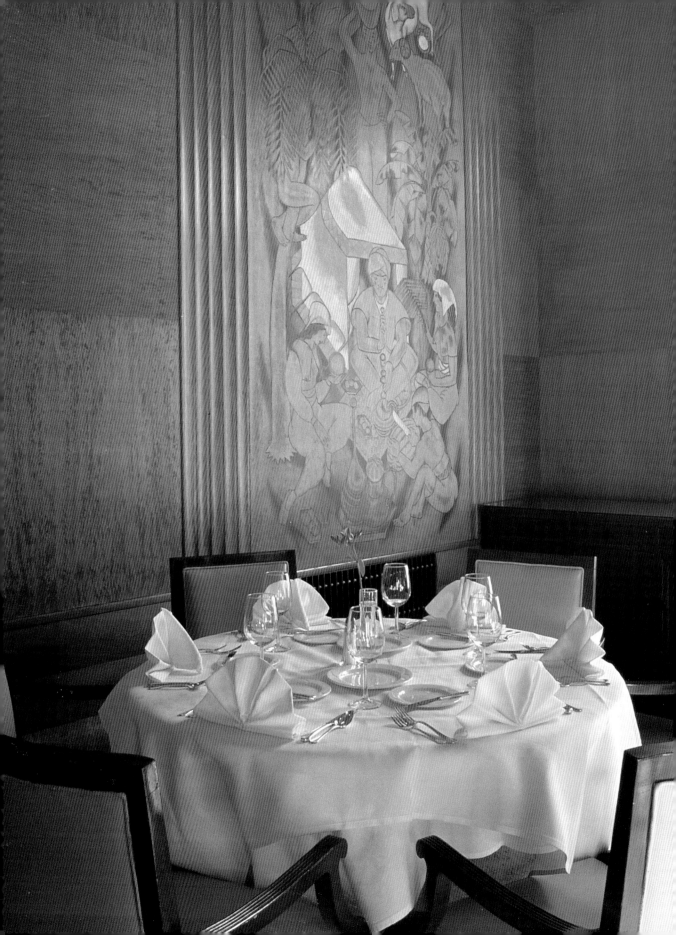

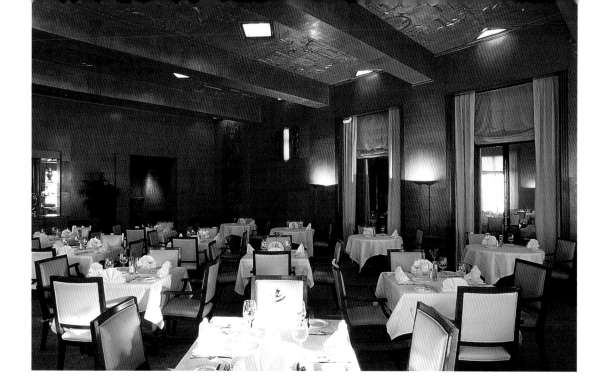

The City Club
155 Sansome Street
San Francisco
415.362.2480
Moderate
In-house catering
Wheelchair accessible

If you're looking for sleek sophistication, you'll find it at the City Club, located in an art deco building that originally housed the administrative offices of the San Francisco Stock Exchange. "Polished" is the best word, both literally and figuratively, to summarize a wedding at the City Club. Shining and glowing with unusual detail are the elevator doors made of copper, German silver, brass, and bronze; the metal balustrade of the grand staircase; the brass-leaf ceiling of the Main Dining Room; and the solid copper cocktail tables in the foyer. An impressive roster of California artists have also contributed to the decorative and architectural elements of the club. The club's centerpiece is famed Mexican artist Diego Rivera's 30-foot-high fresco depicting industry and agriculture, the first fresco Rivera ever created in America.

The entire club, which is on the building's 10th and 11th floors, can be rented for both ceremonies and receptions: the 10th floor (essentially the club's cafe) accommodates 200 seated or 250 standing guests; the 11th floor (the club's main dining room) accommodates 220 seated or 700 standing guests.

The City Club

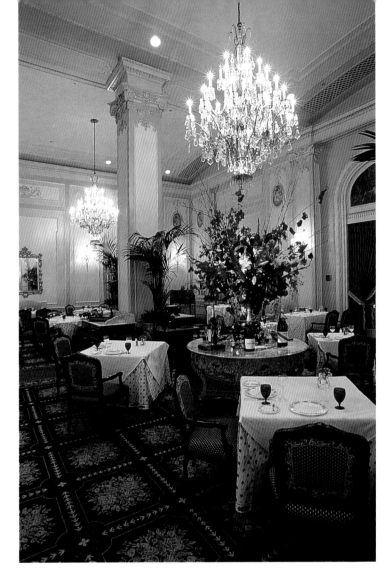

The Yosemite Room is most popular for exchanging vows; it's found on the mezzanine level and has notable chandeliers and woodwork (accommodates 100 seated or 200 standing; used for receptions as well). The Sequoia Room on the 15th floor is great for smaller gatherings—from 20 to 30 seated guests or up to 100 standing guests—and provides a feeling of intimacy with its fireplace and a sense of airiness with its terraces. The most elegant of the event spaces is the hotel's French Room, the hotel's formal dining room. Here, 120 to 130 seated guests or more than 200 standing guests can delight in your union in surroundings so ornate they could have been transported from a European court. The Clift is one of the world's preferred hotels, and amenities such as a concierge, limousines, and excellent fare for your reception are easily at hand.

Clift Hotel
495 Geary Street
San Francisco
415.929.2301
Moderate to Deluxe
In-house catering
Wheelchair accessible

Internationally acknowledged as one of San Francisco's best hotels, the Clift extends its reputation for outstanding service and attention to detail to weddings and receptions. Three rooms are ideal for nuptial fetes and can be rented together or separately.

Clift Hotel

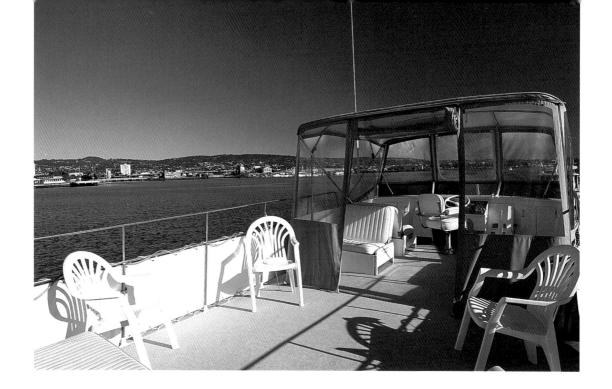

Compass Rose Yachts
San Francisco
415.331.9500
Moderate
In-house catering

It's hard to deny that a wedding while sailing on San Francisco Bay can be spectacular, and for smaller maritime affairs (up to 49 guests) charter a Compass Rose yacht. These fine vessels—which have a completely different feel from larger "party boats"—are luxurious wooden ships that offer a sense of private grandeur. The marble and mahogany interiors of the yachts are impeccable. The chandeliers and tea sets are of crystal and gleaming silver. Say your vows on the deck and host a dinner in a stateroom, salon, or dining room. An executive chef on board can create customized meals for your reception, including a wedding cake; a full bar is available; and music can be amplified throughout the boat.

Guests can even be picked up from any dockside locales for your convenience.

If you're seeking true personal attention and an experience that captures the Bay's panoramic beauty for an intimate wedding event, you'll find it here. No two weddings are alike on Compass Rose yachts, but all share high quality and a first-class nautical manner.

Compass Rose Yachts

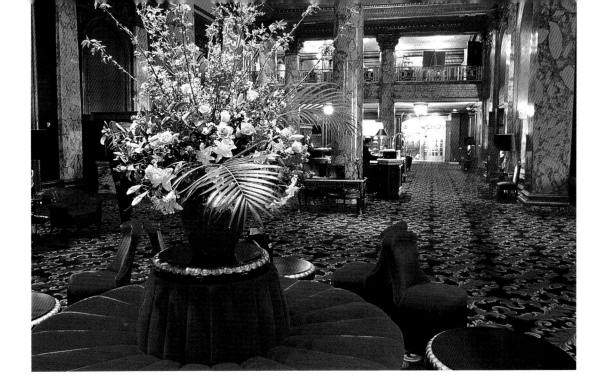

Fairmont Hotel
California and Mason Streets
San Francisco
415.772.5258
Moderate to Deluxe
In-house catering
Wheelchair accessible

A prominent feature of San Francisco's landscape is the glorious Fairmont Hotel (its exterior was seen on the classic television show *Hotel*), atop posh Nob Hill. Splendid celebrations take place here, from the most sumptuous grand-scale affairs to those of smaller scope. The lobby, which has columns and gilt-covered ceilings, welcomes you and your guests. The hotel itself has many rooms in which you can stage your ceremony or reception. The Pavilion Room, which accommodates 150 seated or 300 standing guests, looks over the garden on the hotel's roof. The Gold Room, which accommodates 350 seated or 800 standing guests, has metallic French Provincial details. The luxurious Venetian Room has murals and a 24-foot-liigh ceiling; it accommodates 400 seated, 800 standing. The palatial Grand Ballroom has uniquely patterned carpeting and an indoor balcony and is ideal for an extensive guest list of 1,400 seated and 2,500 standing. For the ultimate in Fairmont style, consider the ten-room Penthouse Suite. Its abundant marble and mahogany, as well as an unusual domed ceiling painted with stars, makes for an unforgettable formal wedding.

Fairmont Hotel

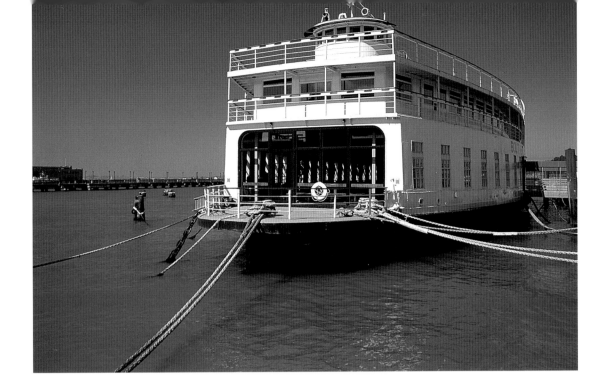

Ferryboat *Santa Rosa*
Pier 3 on the Embarcadero
San Francisco
415.394.8900, extension 227
Deluxe
Preferred caterers list
Wheelchair accessible
on main deck only

If you want a nautical wedding that's overflowing with the charm of eras past and the excitement of downtown San Francisco, the Ferryboat *Santa Rosa* provides them—without ever setting sail. This immaculate, 240-foot-long 1927 ferryboat is now a permanent part of the city's Financial District landscape, as it's docked forever at Pier 3. Most ceremonies take place on the East Fantail Deck, which offers stunning vistas of the Bay for 200 seated or 300 standing guests. Lovely ceremonies and receptions occur on the Sun Deck; it has wraparound views of the city, the Bay Bridge, Treasure Island, and Telegraph Hill. The Sun Deck accommodates 50 seated or 150 standing guests. The West Deck is also available for weddings; it seats 300 or comfortably fits 500 standing guests. The on-staff event coordinator can help you tailor the perfect event. You can even rent the entire vessel for a wedding event your guests will remember for years, as they enjoy a celebration on a magnificent ship, but with the option of dry land always nearby.

Ferryboat *Santa Rosa*

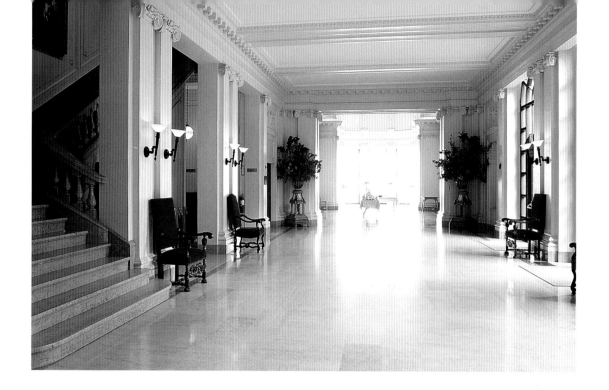

Flood Mansion
2222 Broadway
San Francisco
415.563.2900
Deluxe
Preferred caterers list
Wheelchair accessible

This historic mansion is a classic site for a refined San Francisco wedding, accommodating 300 seated or 450 standing guests on its main floor. Your guests will delight in exploring the 140-foot-long Grand Hall (which seats 200), with its marble floors and spectacular view of the Bay; they will also enjoy the impressive Reception Room (80 to 100 seated), which has a parquet floor and colorful wall murals. They'll love mingling more intimately in the Adam Room (60 seated), which has a marble fireplace and lofty ceiling. And if it's warm enough, they'll venture out into a lovely private courtyard off the Grand Hall (also a good separate venue for 125 seated, 150 standing).

All in all, your guests will be astonished at how immaculately this 1915 Pacific Heights architectural beauty—a hybrid of Italian Renaissance, Georgian, rococo, and Tudor styles—has been preserved. The Flood Mansion is a private school by day, and you can only book this site on Fridays after 3 P.M. and on weekends. You should keep in mind that valet parking is required. Two notable features: a theater is located underneath the main floor that has a capacity of 300 seated, and two baby grand pianos are available for use.

Flood Mansion

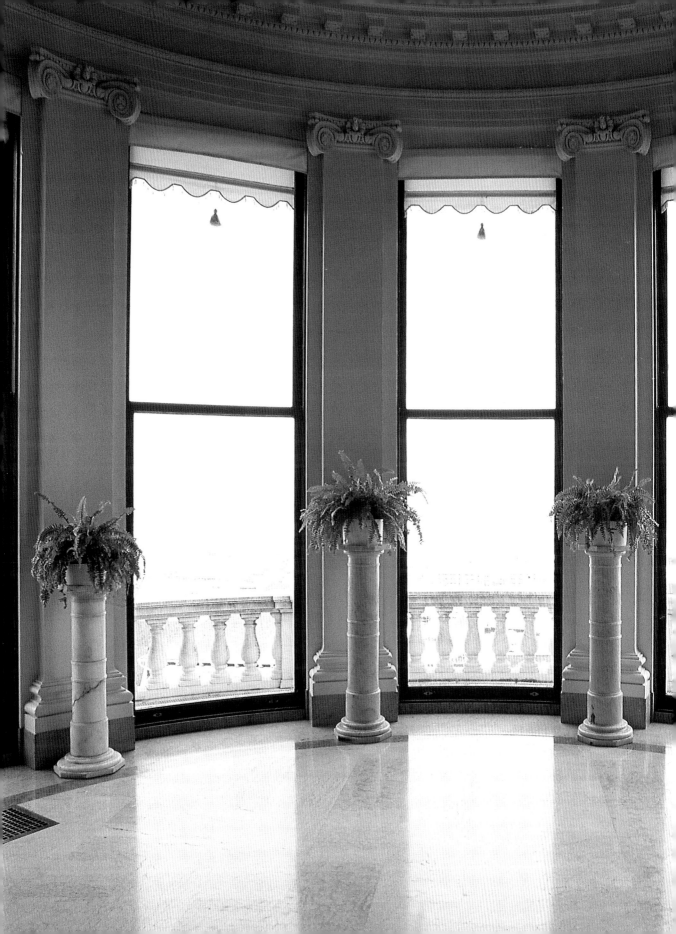

Forest Hill Clubhouse
381 Magellan Avenue
San Francisco
415.664.0542
Moderate

Cozy and friendly: if this is how you'd like your wedding to be remembered, this site provides such charms. Located in the Forest Hill "residential park"—a pleasant neighborhood of homes in the middle of the city—this Bernard Maybeck–designed structure has all the characteristics of the American Arts and Crafts movement that were desirable in the early 1900s. **I**ndoors, dark wood walls and beams, oversized window shutters, and a giant fireplace add to the rustic feel of this building, which accommodates 100 seated or 200 standing guests. The surrounding garden, with a patio shaped like half of a yin/yang symbol, is a charming setting for a small outdoor ceremony; it accommodates 75 seated or 100 standing guests.

The clubhouse has achieved "local legend" status and is well loved by its community. One tale says that neighborhood businessmen built the clubhouse by hand. A known fact is that the neighborhood ladies' garden club voluntarily decorated the women's restroom with floral wallpaper. It's also known that former California governor Jerry Brown's Boy Scout troop met here. For many years, the gardens have been home to a family of doves.

Forest Hill Clubhouse

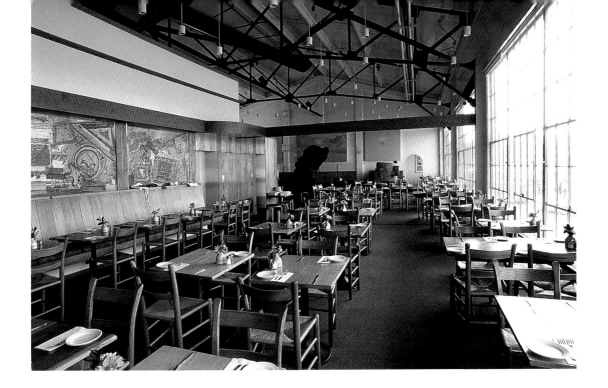

Greens
Fort Mason, Building A
San Francisco
415.771.1635
Moderate
In-house catering
Wheelchair accessible

It's no surprise that Greens exudes a sense of peace. This calm setting, on the waterfront of Fort Mason, is a renowned vegetarian restaurant run by a Zen Buddhist organization. With its rows of windows looking out onto the Golden Gate Bridge and the harbor and Bay, this is a quintessentially San Francisco spot. The space features a lofty ceiling and lots of wood; paintings and sculpture complement the natural beauty seen from the windows (a tip: sunsets are especially stunning from here). Greens accommodates up to 150 seated or 250 standing.

Greens is internationally known for its innovative vegetarian cuisine, and your guests can savor the culinary delights that have established San Francisco as one of the world's top dining spots. Having a wedding at Greens reaches beyond the beauty of its surroundings; rental fees include full meal service—labor, linens, flowers, and candles for four hours (additional time, alcohol, and gratuity must be arranged separately).

Greens

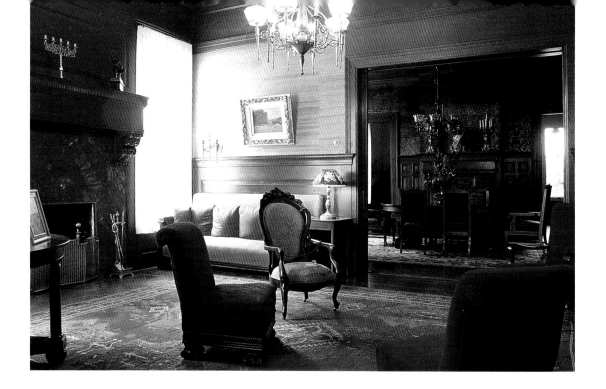

Haas-Lilienthal House

2007 Franklin Street

San Francisco

415.441.3000

Moderate to Deluxe

In 1909, Alice Haas and Sam Lilienthal, members of two of the Bay Area's most prominent families, were married at this dignified Victorian home that now bears their names. The popular landmark remains an inviting and homey wedding venue, with classic interior woodwork and original furnishings from the early 1900s.

The Haas-Lilienthal house is a San Francisco treasure because it is a rare existing example of the standard yet fashionable Italianate Queen Anne–style row houses that lined once-quiet, exclusive Franklin Street—now a busy main artery of the city.

You can't miss the Haas-Lilienthal House. Its exterior is a distinctive steel gray—a popular hue at the time it was built. Today, you can wed in either of the two parlors of the house, which combined accommodate 60 seated or standing guests for ceremonies; receptions can be held for 80 seated or 200 standing guests on the high-ceilinged main floor of the house or in the downstairs ballroom.

Haas-Lilienthal House

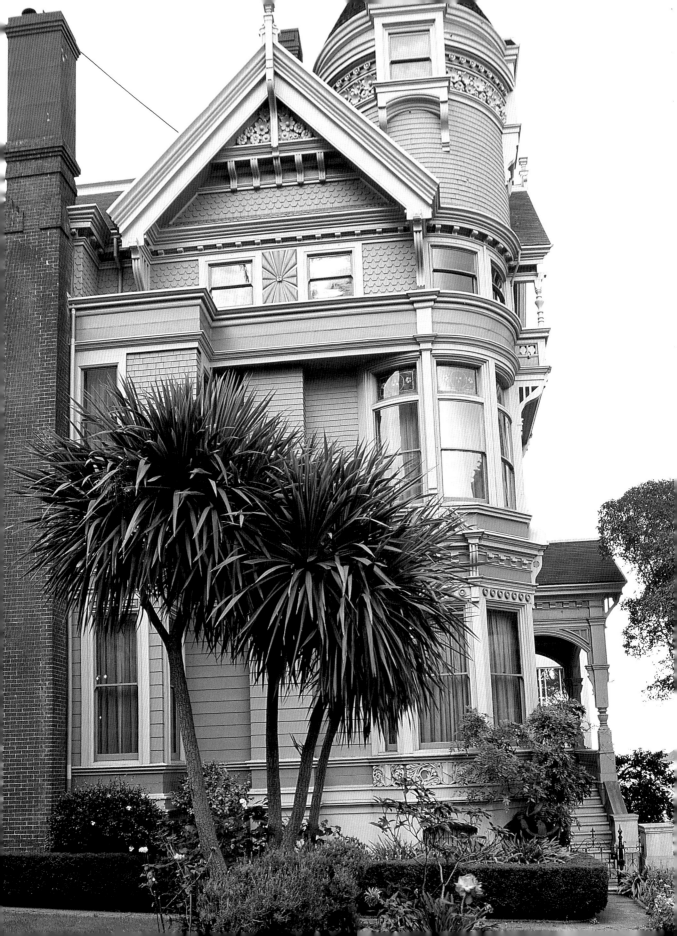

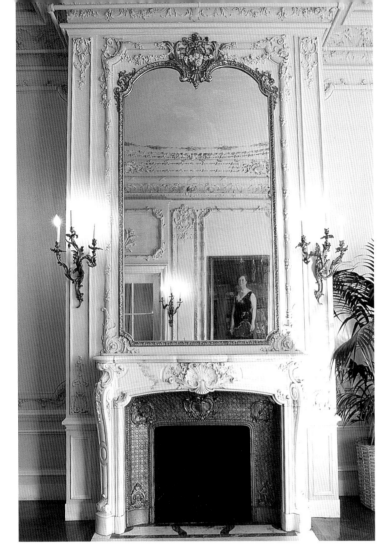

a private school, but by night, it's a genteel site for rejoicing. Ceremonies at the Hamlin Mansion generally take place in the Grand Hall (100 seated guests, with space for 80 additional guests around the balcony), which showcases columns made of oak, patterned hardwood floors, a two-story ceiling, and a marvelous skylight crafted of leaded glass. Brides will make an unforgettable entrance as they descend the grand staircase. Other available sections of the Mansion include the lovely Solarium; the Main Dining Room, which provides views of San Francisco Bay through its large windows; and more upstairs rooms that convey a sense of grace. The entire mansion can be rented, and it seats 176 guests or holds 250 standing guests. Event coordination is offered. Valet parking and security are available for additional fees.

Hamlin Mansion
2120 Broadway
San Francisco
415.331.0544
Deluxe
Catering provided
Limited wheelchair access

For a first-class wedding in a grand tradition, look no further than the Hamlin Mansion, located on Broadway, one of San Francisco's most luxurious residential streets. By day, this is

Hamlin Mansion

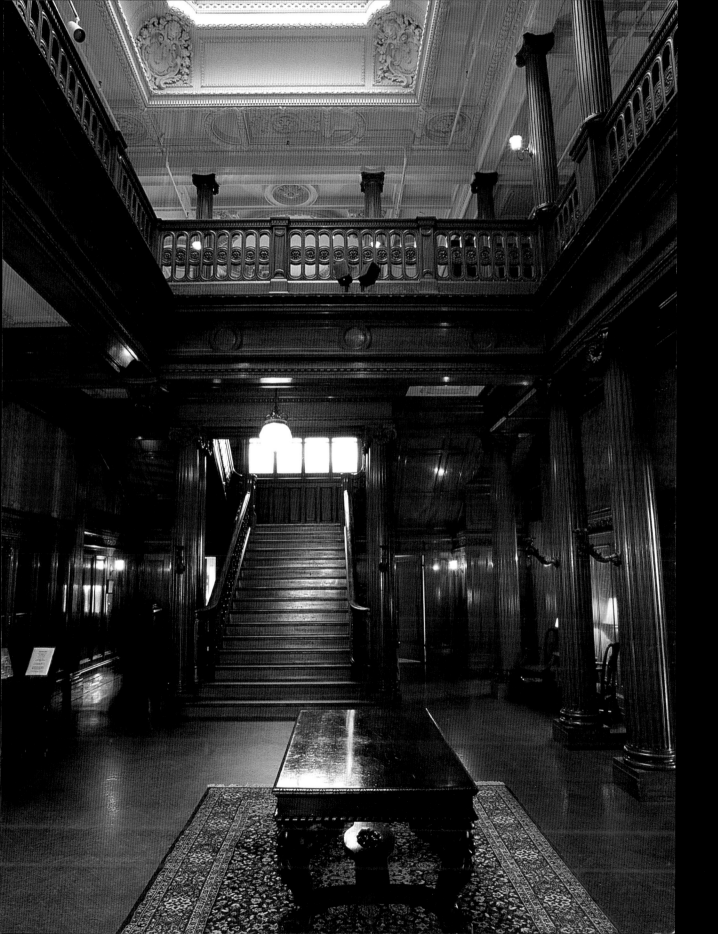

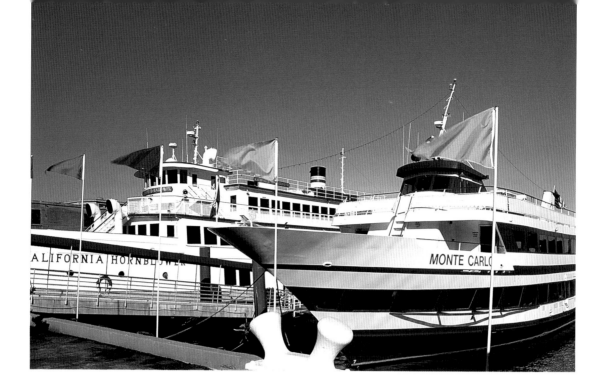

Hornblower Dining Yachts
Pier 33 on the Embarcadero
San Francisco
415.788.8866, extension 6
Deluxe
In-house catering
Wheelchair access varies
with ships

Picture saying your vows and dining and dancing with your family and friends under the blue sky of San Francisco—afloat on the Bay itself, with the city and its legendary bridges as an unforgettable backdrop. All are possible aboard the Hornblower Dining Yachts, a San Francisco– and Berkeley-based fleet of elegant ships.

Whether you're organizing a quiet celebration for 50 (aboard the *Papagallo II*, *Captain Horn- blower*, or *Admiral Hornblower*) or a blow-out for 800 seated or 900 standing guests (the dramatic *California Hornblower*), you can stage a unique cruise. There are other crafts to choose from, depending on your needs: the *Monte Carlo* accommodates 300 seated, 450 standing; the classic *Empress Hornblower*, 260 seated, 375 standing; and the *Commodore Hornblower*, 110 seated, 135 standing. Standard amenities on all boats include linens, china, silverware, and even flowers. The ships' captains can marry you at sea, and the experienced staff can oversee everything from invita- tion printing to the ordering of personalized mementos. Wedding packages are available for each cruise, including a sophisticated Dinner Dance (lovely with city lights sparkling across the water) and a sunny Champagne Brunch Cruise, or you can tailor your own event.

Hornblower Dining Yachts

Limn Gallery
292 Townsend Street
San Francisco
415.543.5466
Moderate to Deluxe
Preferred caterers list
Wheelchair accessible

For a chic urban wedding, look no further than Limn Gallery in the ultra-hip South of Market district. Its two large, well-lit rooms are situated on opposite sides of a central entrance gallery; the entire space surrounds three sides of a 2,500-square-foot courtyard. Available daily, the gallery is quickly gaining a reputation as one of the city's premier spots for top-notch fine art exhibitions and stylish parties.

The entire gallery can accommodate 200 seated, 300 standing; the courtyard alone (a tent is available for an additional fee), 65 seated, 150 standing. The interiors are streamlined, with sealed concrete floors and off-white plaster walls. The sophisticated lighting—installed to showcase the works of art on display—ensures a cultured atmosphere. The elaborate indoor/outdoor sound system can also lend drama to your event. Although there is a distinctly urban feel to Limn Gallery, there is also plenty of traditional elegance in the courtyard, such as the lovely gate, stone inlays in the floor, potted greenery, and decorative blossoming vines.

Limn Gallery

Main Post Chapel at the
Presidio
Fisher Loop (at Sheridan and
Infantry Terrace)
San Francisco
415.561.3930
Very Affordable
Wheelchair accessible

Surrounded by eucalyptus and pine trees and offering a stunning view of the Golden Gate Bridge, Alcatraz and Angel Islands, and the downtown skyline, the Main Post Chapel embodies the timeless essence of San Francisco. It is also a place of deep tranquillity. In fact, the chapel was built on land long deemed as sacred by the Ohlone Indians.

For decades, this classic Spanish Colonial Revival chapel, built in 1931, had been a favorite spot for military personnel to exchange vows. Now that the Presidio, a former base, is part of the Golden Gate National Recreation Area, the public can wed at this hilltop interfaith sanctuary. Up to 175 seated guests can be accommodated comfortably in the chapel, where a pipe organ plays. Wrought-iron chandeliers dangle from a ceiling lined with redwood beams. Oak doors and stained-glass windows are in the distinct style of old mission churches.

Small receptions for up to 60 can take place inside the Mural Room, named for its painting of St. Francis, created in 1935 by Victor Arnautoff. Arnautoff was a leading artist of his generation and is credited with the murals found at Coit Tower. A small outdoor garden can serve as a pre- or post-ceremony mingling area.

Main Post Chapel at the Presidio

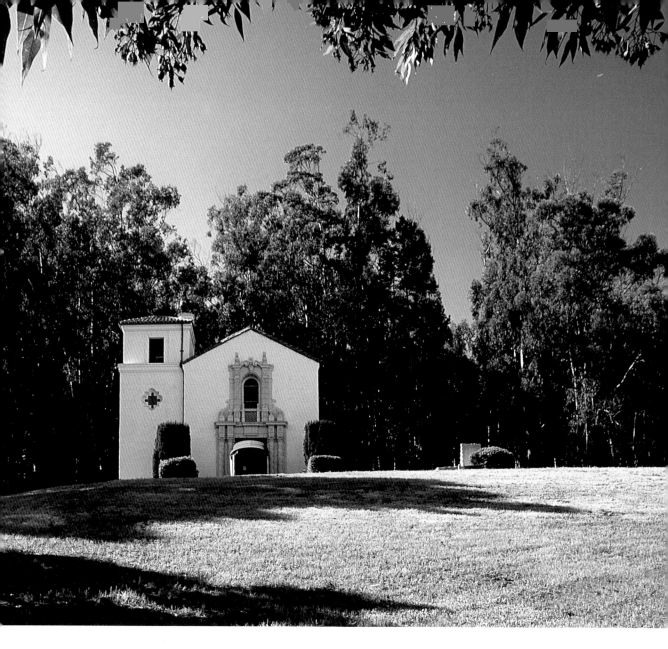

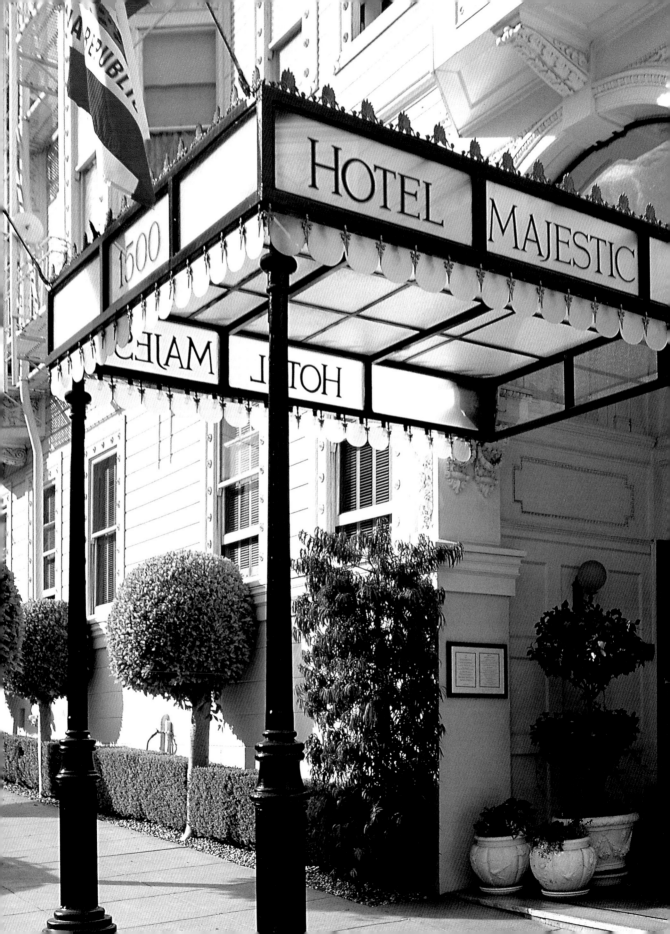

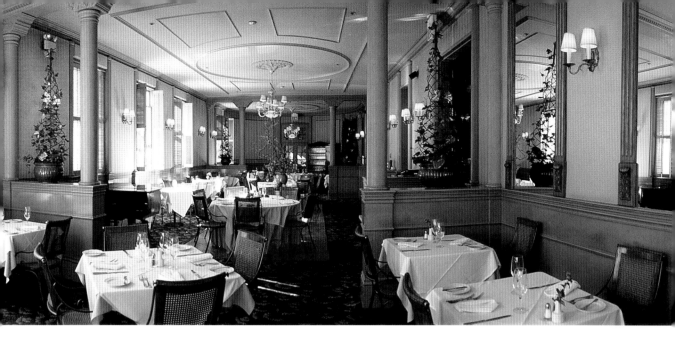

The Majestic
1500 Sutter Street
San Francisco
415.441.1100
Moderate
In-house catering
Wheelchair accessible

Originally constructed as the private residence of Milton Schmitt, a railroad baron and member of the California State legislature, this 1902 Edwardian structure later became the home of movie stars and sisters Joan Fontaine and Olivia de Havilland for almost a decade. More recently, the impeccably restored building was a recipient of the California Heritage Council's prestigious Certificate of Recognition for Architectural Preservation and Restoration. Antiques imported from London and Paris, as well as Chinese screens and Empire-style chandeliers, add to the grandeur of the lobby and private suites; the restaurant's bar features one of the world's most notable collections of rare preserved butterflies from Africa and New Guinea.

The warm hospitality of the Majestic's staff shines through at weddings celebrated here. Ceremonies for up to 50 guests can be accommodated in the restaurant; receptions can be accommodated in the same venue for 20 to 120 seated guests. Lavish suites—named after the San Francisco luminaries who have stayed in them, such as legendary newspaper columnist Herb Caen—are available for smaller gatherings.

The Majestic is on a tree-lined street, among notable Victorian buildings. It seems far from the sometimes chaotic environment of downtown, although it is easily accessible from all parts of the city. Special room rates can be arranged for your wedding party.

The Majestic

The Marines' Memorial Club
609 Sutter Street
San Francisco
415.673.6672
Deluxe
In-house catering
Wheelchair accessible

Weddings are the specialty of the Marines' Memorial Club, by their own admission—and they have a reputation for proving this claim with attention and style. Originally constructed as a formal women's club in 1910, this build-ing makes a spectacular setting for your event, with elaborate chandeliers and luxurious archi-tectural details, including fine marble fireplaces, ornate wood carving, and shiny parquet floors. In 1946, the club became a memorial to Marines who lost their lives during World War II; sponsorship is required to hold a wedding here, but a referral from anyone who has served in a U.S. military branch suffices.

For the utmost in grand events, the palatial Crystal Ballroom— named for its chandeliers—is fit for a princess and seats 150 to 200. The Commandant's Room is even larger and features a 40-foot ceiling, iron chandeliers and sconces, and stately enameling and stencil details along the walls and ceiling. For smaller affairs, the Tudor-style Regimental Room provides seating for 20 to 60, while the Heritage Room sup-plies Victorian chandeliers and lovely views of Nob Hill and the San Francisco Bay for 20 to 50 seated guests.

The Marines'
Memorial Club

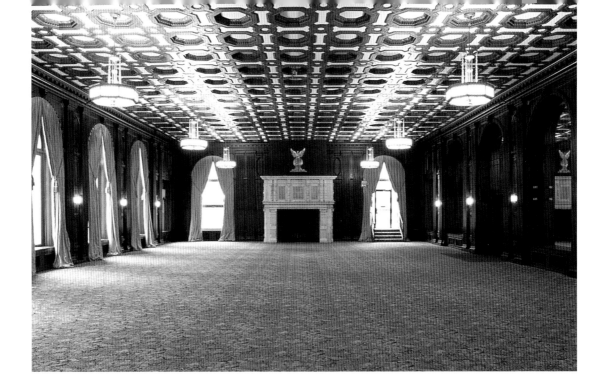

Merchants Exchange Ballroom
465 California Street
San Francisco
15th floor
415.421.7730
Moderate to Deluxe
Wheelchair accessible

Located in one of San Francisco's more notable beaux arts buildings, right in the hub of the city's Financial District, this site conveys a sense of tradition and dignity. The structure itself has an illustrious past: created in 1903 by Willis Polk, it was one of the city's first steel-framed "sky scrapers"; its structure was so strong, it survived the 1906 earthquake.

The Merchants Exchange Ballroom is on the 15th floor in the former quarters of the Commercial Club, a historic men's club that has recently been remodeled. The elements that made the Commercial Club so handsome are still evident: vaulted ceilings, dark wood paneling, and a giant carved-stone fireplace. The ballroom is stately, with a majestic color scheme, and accommodates 390 sit-down guests or 1,000 standing guests. The lounge has an elegant mahogany bar and is a sophisticated environment for guests to visit with one another. Even the lobby, complete with working fireplace, is a distinctive area that your guests will enjoy. Ask about renting the boardrooms for smaller ceremonies and receptions, as additional party spaces, or for a bride's changing room.

Merchants Exchange Ballroom

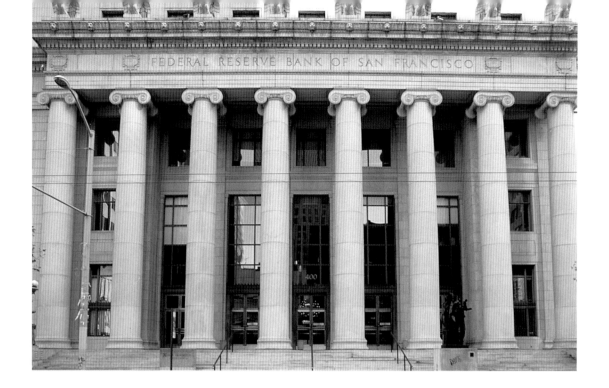

Old Federal Reserve
Bank Building
400 Sansome Street
San Francisco
415.392.1234
Deluxe
Preferred caterers list
Wheelchair accessible

Although it might not seem romantic to wed in the lobby of the 1924 Old Federal Reserve Bank, located in San Francisco's bustling Financial District, this is nonetheless one of the city's best venues for romantic events. The site has fine European marble, 25-foot-high classical columns, and stunning bronze chandeliers (created by the original designer) and is listed in the National Register of Historic Places. The sheer physical capacity (150 to 400 seated, 600 standing) is that of a large, dignified public space, while the building also offers the sophisticated panache of a landmark mansion. A staircase, carved from the building's signature marble and decorated in bronze, can provide a truly unforgettable entrance for a beaming, beautiful bride. Because this building does function for business during the day, events are generally scheduled between 5 P.M. and 1 A.M., but exceptions can be made. And don't worry—dramatic velvet curtains help camouflage any evidence of the Old Federal Reserve's daytime identity.

Old Federal Reserve
Bank Building

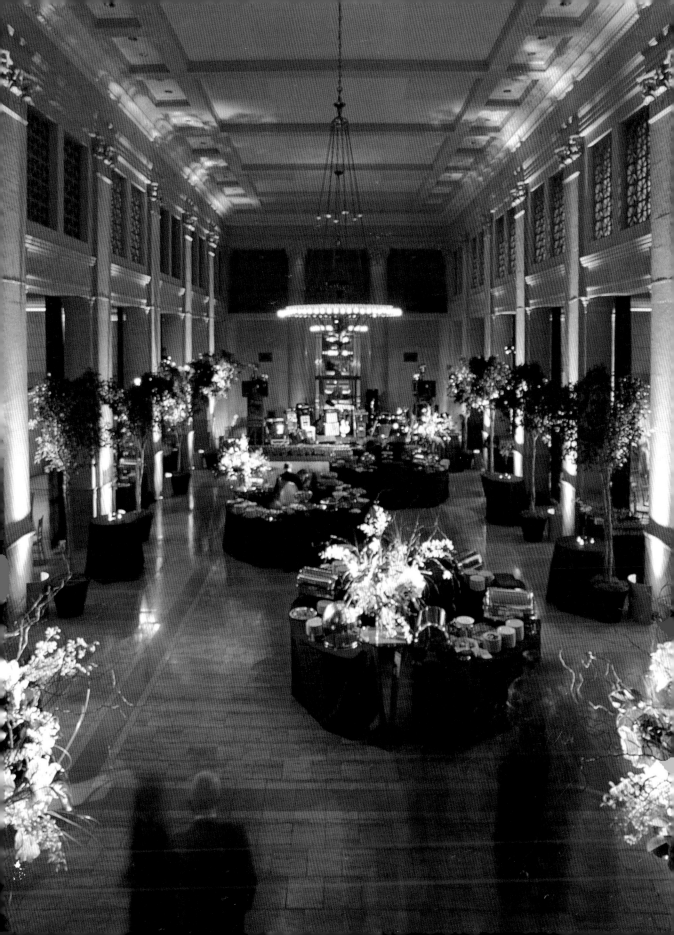

Palace of Fine Arts Rotunda
Marina Boulevard and
Lyon Street
415.831.2790
Very Affordable
Wheelchair accessible

This Bernard Maybeck–designed neoclassical rotunda is as breathtakingly beautiful as the most gorgeous of bridal dresses. Built as the showcase for the 1915 Pan-Pacific Exposition, the Palace of Fine Arts Rotunda is one of San Francisco's most romantic structures. Swans glide across the lagoon that surrounds it; trees and flowers bloom around the grounds. Statues of weeping women—legend has it that they symbolize the sadness of a world without art—decorate the colonnade. Although only a facade (the building behind the rotunda houses the Exploratorium, a hands-on science museum), the Palace of Fine Arts has a soaring, giant dome in which statues of angels are perched high above.

Underneath this dome, up to 250 seated or standing guests can be accommodated for a wedding or reception (tents and portable heaters are recommended for winter months; portable toilets also must be rented). Although lovely by day (in fact, hundreds of brides and grooms visit this site to be photographed against the fairytale backdrop), nighttime events are spectacular because the dome and statues are lit dramatically.

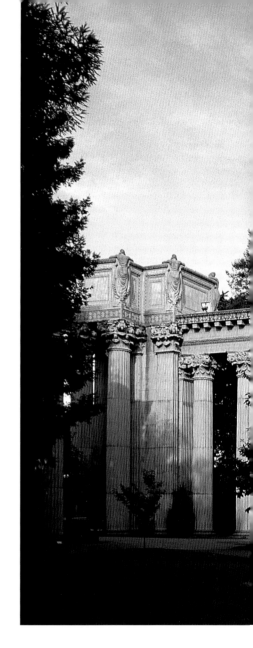

Palace of Fine Arts Rotunda

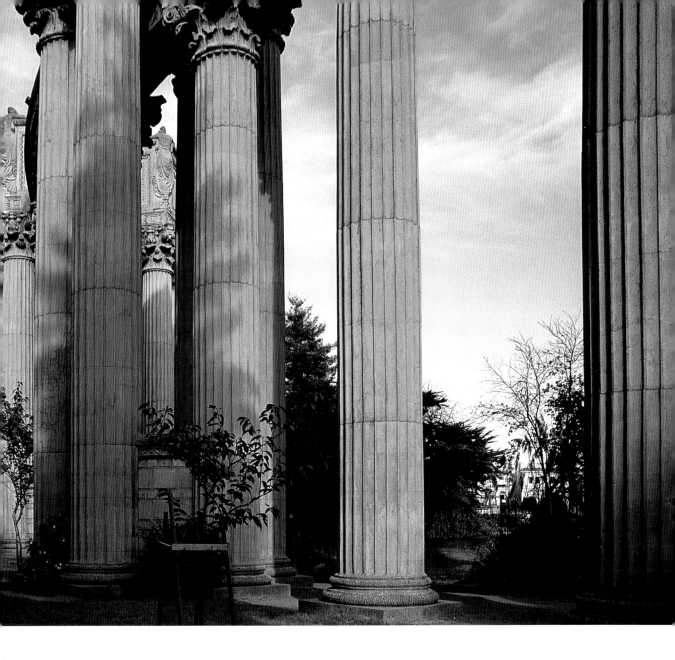

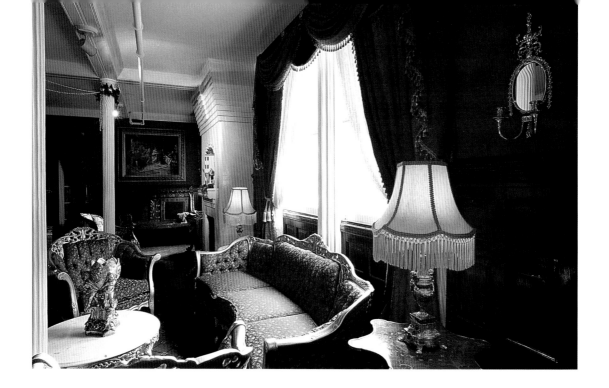

Queen Anne Hotel

1590 Sutter Street

San Francisco

415.441.2828

Moderate

Preferred caterers list

Wheelchair accessible

This classic Victorian building is a distinctly San Francisco wedding site. Built in 1890, the Queen Anne has been a finishing school for girls, a private gentlemen's club, and a shelter for young mothers. Today, it's a quaint bed and breakfast that exemplifies the Queen Anne style of architecture for which the inn is named. Interior details, such as restored wood paneling and inlaid floors, also hark back to a bygone era.

Ceremonies take place in the inn's parlor, which seats 65 guests. Brides can descend a charming staircase to make a grand entrance.

The salon and library areas, furnished with charming English antiques and fireplaces, together accommodate 80 seated or 150 standing guests for receptions. The salon features a dance floor and opens onto a small courtyard.

Queen Anne Hotel

Ritz-Carlton Hotel
600 Stockton Street
San Francisco
415.296.7463
Deluxe
In-house catering
Wheelchair accessible

The only hotel in San Francisco designated as both "Five Star" and "Five Diamond," the luxurious Ritz-Carlton clearly deserves the same high praise as a wedding site. A classic colonnade and frieze adorn the dramatic facade of this landmark; inside, fine 18th- and 19th-century paintings and antiques add to the hotel's distinctive decor. The Ritz-Carlton's worldwide reputation for impeccable service extends to its wedding amenities—which include complimentary accommodations for the bride and groom. Ceremonies take place in a garden-enclosed courtyard with views of the city's skyline; this site accommodates 300 seated or 400 standing guests. (You can also have your reception here, for 170 seated or 200 standing guests.) For a larger guest list, ceremonies and receptions can take place in the Ritz-Carlton Ballroom, an immense space that accommodates 735 seated or 826 standing guests. The Ballroom can be broken down into three separate Salon spaces as well, to accommodate groups of 245 seated or 275 standing guests, or 123 seated, 137 standing guests. The menus at the regal Ritz-Carlton are inspired—readers of *Gourmet* magazine, in fact, voted the Ritz-Carlton's cuisine to be San Francisco's best.

Ritz-Carlton Hotel

Rose Garden
Golden Gate Park
Park Presidio Boulevard and
Fulton Street
San Francisco
415.831.2790
Very Affordable
Limited wheelchair
accessibility

Surround yourselves with roses in this pleasant garden as you say your vows and celebrate your wedding—right in the midst of lively Golden Gate Park. Up to 100 standing or seated guests can gather here for ceremonies and receptions among a collection of diverse breeds of the world's most romantic flower. Imagine a wedding day spent traipsing through the meadows, trails, and woods of Golden Gate Park before or after your ceremony. Your guests will enjoy the festive ambience of San Franciscans enjoying the outdoors in one of the nation's largest urban parks. The rainbow of blooms offered at the Rose Garden adds a stunning sense of natural beauty to a wedding, and the garden offers affordable and effortlessly elegant decor. Keep in mind that you will have to rent chairs and all other furnishings for your event. Nevertheless, for a simple outdoor wedding, this is a delightful site.

Rose Garden

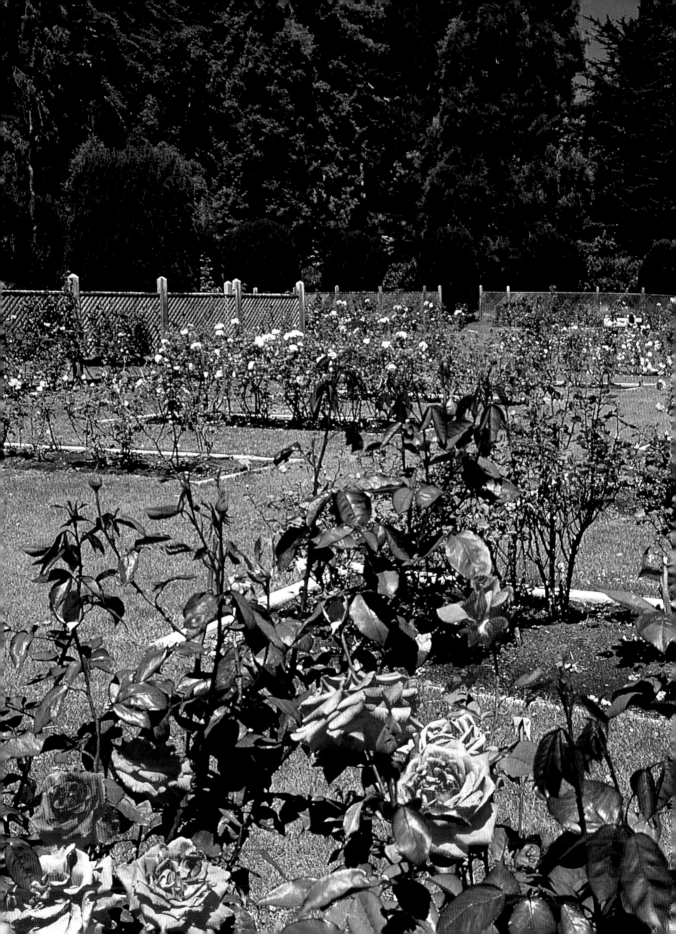

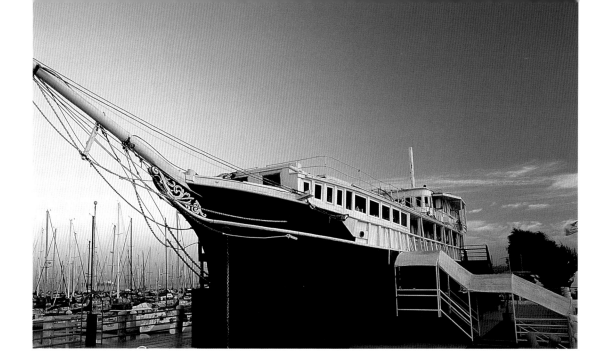

Sailing Ship *Dolph Rempp*
Piers 42 and 44 on the
Embarcadero
San Francisco
415.777.5771, 415.543.4024
Very Affordable
In-house catering
Limited wheelchair
accessibility

If it's a slice of history you're seeking, or a truly unusual experience for your guests, consider the Sailing Ship *Dolph Rempp*, perched on a bed of seismically safe concrete in the lively South Beach area. Built in 1887, this ship transported wine and spirits to England, Scandinavia, and Russia from its native Bordeaux, France. It carried supplies in World War I and served as an espionage vessel in World War II. **D**uring the Prohibition era, the ship was a rumrunner. Later, it was "discovered" by Hollywood producers; you might recognize it from *Mutiny on the Bounty*. In 1973, it sailed to San Francisco. **A**s a wedding venue, it offers views of the San Francisco Bay, the Bay Bridge, the city skyline, and the twinkling lights of the East Bay. While the ship's exterior shows its age as a weathered three-masted schooner, the interior features gleaming brass and gentle candlelight, as well as flowers and the de rigeur nautical decor. Also a plus: the ship's restaurant has drawn raves from national food journalists. **F**or ceremonies, the Captain's Deck can hold 50 seated, 200 standing guests; the Back Deck holds 125 seated, 175 standing; and the Outside Front Deck accommodates 300 seated only. For receptions, the entire vessel can accommodate 800 standing guests; 175 guests can be seated on one level of the ship, while seating for 200 additional guests can be arranged on the back deck.

Sailing Ship *Dolph Rempp*

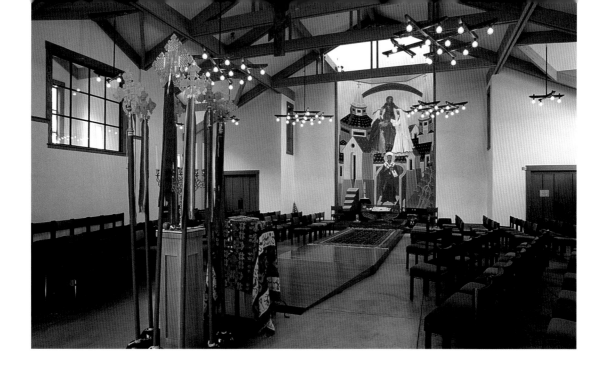

St. Gregory Nyssen Church
500 De Haro Street
San Francisco
415.255.8100
Very Affordable
Wheelchair accessible

Bold and eclectic in its design and its approach to spiritual celebration, St. Gregory's has received much attention for its pioneering architecture—it was inspired by filmmaker Akira Kurosawa's *Ran* as well as by Byzantine plans. This church, which is Episcopalian, even has a Zen-style Japanese fountain. **W**ith the altar in the center, the sanctuary's layout recalls that of older European basilicas, dating back to an era when congregational participation was encouraged. The 6,600-square-foot structure took seven years to plan, design, and fund; the result is a distinctly Californian church, with nods toward Bernard Maybeck's style, reflected in the hefty yet elegant exposed beams that hold St. Gregory's cupola above the central altar. Intriguing, contemporary icon paintings, commissioned exclusively for the church, add color to the otherwise minimally decorated space. Sacred decorations reflect the diversity of the ceremonies held here, including singing bowls from Tibet and an early 19th-century menorah. Combining the unexpected and the rich traditions of the world's religions, this recently erected, one-of-a-kind church will leave a memorable impression on your guests.

St. Gregory Nyssen Church

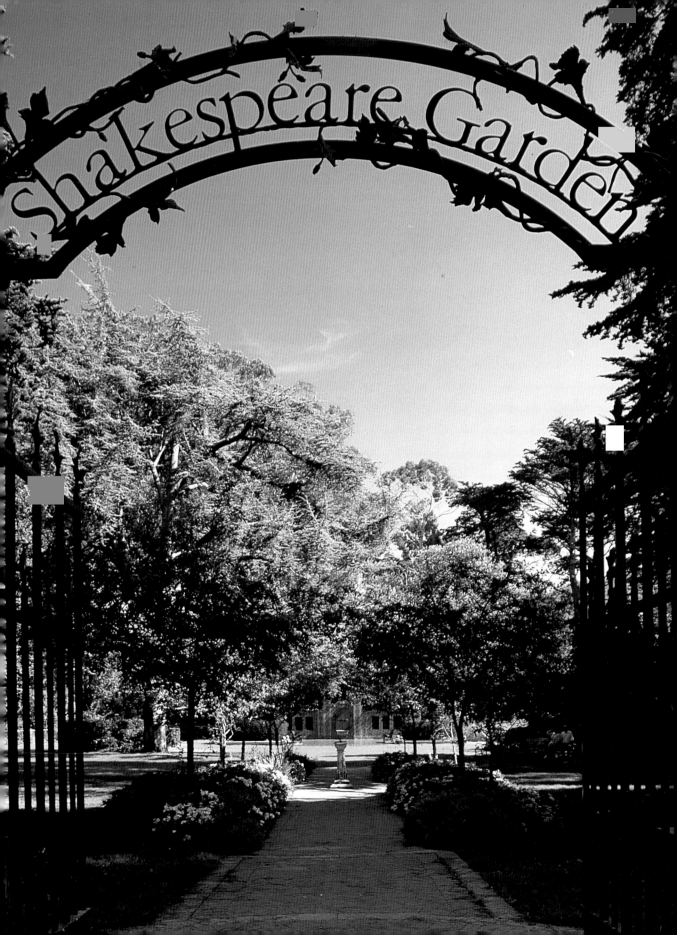

Shakespeare Garden
Golden Gate Park
Martin Luther King Drive
San Francisco
415.831.2790
Very Affordable

Sprawling Golden Gate Park is the heart of the city, both literally and metaphorically, offering within its grounds a brief reprieve from urban life. Nestled within the park is a lovely glen sur- rounded by trees and tucked away from the well-traveled paved roads. Easy to find (despite its quiet location behind the Academy of Sciences), this glen is such an appropriate spot for outdoor performances that it's used for public productions of Shakespeare. Having a wedding here—for 200 guests, standing or seated—you could create your own celebratory pageant like *A Midsummer Night's Dream* or a more private love scene from *Romeo and Juliet*. This is one of the city's official "designated sites for weddings" on San Francisco Recreation and Park Department grounds, and it is a rare public yet private space. Who would have thought it would be so easy to create a wedding scene that would rival the most merry of the Bard's? This is an outside cere- mony or reception site that's sure to inspire a sonnet or two.

Shakespeare Garden

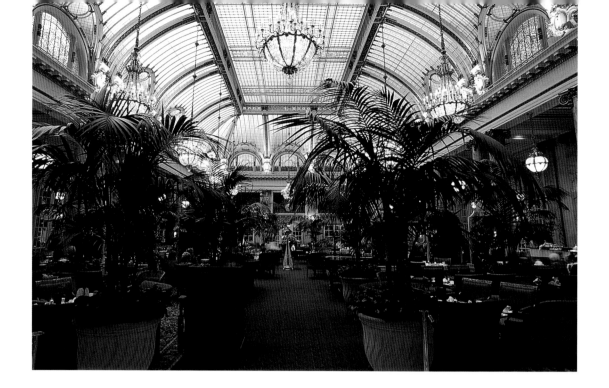

Sheraton Palace Hotel
2 Montgomery Street
San Francisco
415.546.5012
Moderate to Deluxe
In-house catering
Wheelchair accessible

Steeped in history and elegance, the Palace Hotel prides itself on being an institution without peer. Woodrow Wilson gave his famed League of Nations speech in the Garden Court—home of the largest free-standing expanse of stained glass in the world. It was also the setting for a special wedding so spectacular that it was featured in a television documentary. You must make special arrangements to hold a wedding in this area of the hotel, but bridal teas are most welcome here.

The French Parlor, which accommodates 100 seated or 150 standing guests for ceremonies or receptions, offers a stunning overhead view of the Garden Court. Weddings also occur in the inspiring Ralston Room, which accommodates 275 seated or 600 standing guests. You can have a reception for 600 seated or 1,000 standing guests in the Grand Ballroom, which has dazzling chandeliers. The Gold Ballroom, named for the glittering gold-leaf details in its decor, seats 275 guests or holds 600 standing guests. For a more modern ambience, the Sunset Court, with a glass dome, accommodates 300 seated or 600 standing guests. And bear in mind that with every wedding hosted here, a complimentary suite is offered to the bride and groom, complete with a chilled bottle of bubbly.

Sheraton Palace Hotel

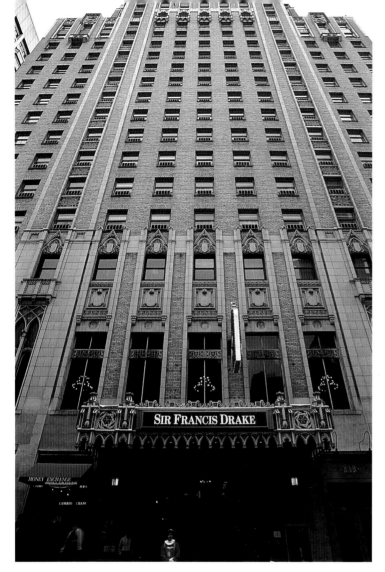

tie weddings as well as the most chic of modern affairs. The hotel's lobby, with its marble columns and gold-leaf ceilings, harks back to bygone elegance. The Empire Ballroom, which accommodates 250 seated and 350 standing guests, also displays such splendor, with its gold ornamentation and crystal chandeliers. The Franciscan Room, which seats 140 and has a capacity for 200 standing guests, is just as sophisticated, with murals, a 21-foot ceiling, and adjacent anteroom with ten-foot-tall windows and doors. The hotel's mezzanine, off of which is the Franciscan Room, is a stylish area for guests to socialize and enjoy prereception hors d'oeuvres. For a more cosmopolitan celebration, try Harry's Starlight Room (150 seated or 200 standing guests) on the hotel's top floor; its dance floor and baby grand make it a great place for a party. Here, guests can dance high above the city, looking down at the sparkling lights.

Sir Francis Drake Hotel
450 Powell Street
San Francisco
415.392.7755
Moderate
In-house catering
Wheelchair accessible

There are few images more symbolic of San Francisco's spirit than the Beefeater-costumed doormen at the Sir Francis Drake Hotel, a looming Gothic-style skyscraper found near Union Square. This landmark hotel can host the most traditional black-

Sir Francis Drake Hotel

Spectrum Gallery
511 Harrison Street
(at 1st Street)
San Francisco
415.495.1111
Deluxe
Open to all caterers
Wheelchair accessible

In many ways, putting together a wedding is like producing a movie. Spectrum Gallery, an art gallery that doubles as a state-of-the-art event space, is the ultimate soundstage for unique, ultra-urban ceremonies and receptions. Why unique? Because there are no restrictions on entertainment, and the hip, loft-like space, which has breathtaking views of the San Francisco skyline, can be transformed to your tastes. Spectrum can accommodate up to 400 seated and 650 standing guests (and can be rearranged for smaller functions); it was designed by a former wedding planner, who knows from a decade of experience how to create the most unforgettable of occasions. The lighting and sound systems have features usually found only in the most sophisticated of theaters, so you can dance under dramatic spotlights or dim them to "candlelight" as dinner is served. Museum-quality paintings and sculptures are on display. During the day, sunlight streams in from rows of windows 20 feet high, while at night, the city's lights dazzle. There are other amenities that make Spectrum a great find: abundant on-street parking, unusually huge restrooms, an open-to-all-caterers policy, and daily availability.

Spectrum Gallery

Stern Grove
19th Avenue and Sloat
Boulevard
San Francisco
415.831.2790
Very Affordable to Moderate
Wheelchair accessible

Would you like to disappear into a magical forest that's perfumed with the fragrance of eucalyptus trees—without leaving San Francisco? At a Stern Grove wedding, you can find such an escape. Ceremonies and receptions make use of the Grove's cozy clubhouse (which seats 125 guests), as well as the building's immediate surroundings. You might consider having an outdoor ceremony followed by drinks and a feast indoors, as the shady grove tends to be slightly chilly, adding to the woodsy ambience. The clubhouse's fireplace is sure to warm you up.

The clubhouse features a large multipurpose room where guests can dine or dance, a wet-bar area where everyone can mingle casually, and a commercial kitchen for use by the caterer you provide. The sheltering trees and the leaves rustling in the wind lend a feeling of serenity to weddings taking place in this remarkable forest-within-the-city.

Stern Grove

Swedenborgian Church

2107 Lyon Street

San Francisco

415.346.6466

Very Affordable

If you'd like a serene wedding, consider the sanctuary of the Swedenborgian Church, in a quiet section of Pacific Heights. Before building the church, the cofounders declared their goal was to produce a "poetry of architecture," and they have achieved it. Built in 1895 by a consortium of artists and architects along with a spiritual community, this unusual Arts and Crafts style chapel (with nods to Mission architecture) was inspired by the peaceful aspects of nature. Nature herself is present in the landscaped, walled-in lawn and garden, which is a delightful spot for pre- and postceremony gatherings among trees from around the world, blooming flowers, and a small pool. Inside the chapel, the warm light of more than 60 candles and San Francisco's largest public fireplace greets up to 115 seated or 150 standing guests. Ceremonies can be tailored for any need, including traditional, interfaith, and contemporary. The adjacent Parish House, which offers the cozy Library and the Garden Room, complete with deck, and is also available as a reception spot for 60 seated or 100 standing guests.

Swedenborgian Church

Temple Emanu-El
2 Lake Street
San Francisco
415.751.2535
Moderate
Preferred caterers list
Wheelchair accessible

Exotic and magnificent in its Middle Eastern design, Temple Emanu-El is a wedding venue that projects a welcoming warmth. Ceremonies can occur in one of four venues, depending on the size of your guest list. The stunning main sanctuary seats up to 1,500 under its massive dome. The space has stained-glass windows, which fill the space with color and radiant light, and splendorous black and gold chandeliers. The main sanctuary's foyer is now also available and seats up to 200. The smaller Martin Meyer Sanctuary, with arched doorways, a balcony, and deeply hued walls, seats 275.

A chapel is available for intimate ceremonies of up to 100 seated guests.

The temple's outdoor courtyard, with water bubbling in its central fountain, is a divine environment for an outdoor reception, weather permitting. There are two downstairs entertainment halls, Guild Halls 1 and 2, which were designed for hosting festivities. These rooms feature high-tech sound and lighting, as well as dancing areas and a stage. Each of the Guild Halls seats 120 or accommodates 300 standing guests; rented together, they seat 230 and provide ample space for 600 standing guests.

Temple Emanu-El

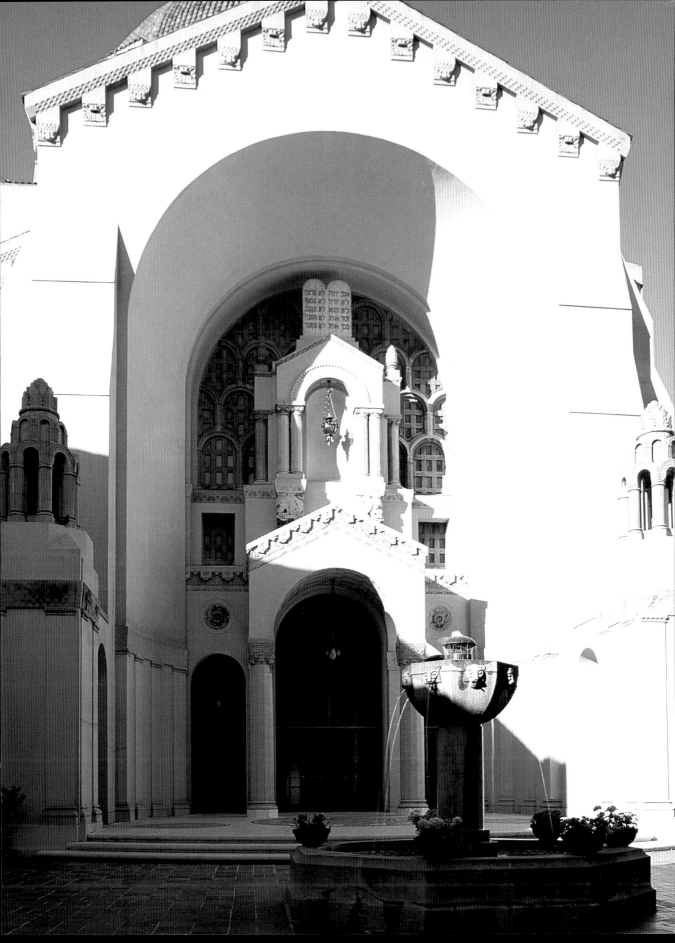

Ardenwood Historic Preserve

Bancroft Hotel

Berkeley City Club

Brazil Room, Tilden Park

Claremont Resort and Spa

Crow Canyon Country Club

Danville Station

Dunsmuir House

Elliston Vineyards

Faculty Club, University of California, Berkeley

First Unitarian Church of Berkeley

Hacienda de las Flores

Heather Farm Garden Center

Lake Merritt Sailboat House

Montclair Women's Club

Murietta's Well

Palmdale Estates

Piedmont Community Center

Preservation Park

San Ramon Community Center

Shadelands Ranch Historical Museum

Valley Oak Nursery

east bay

It's hard not to think of the romance of the Victorian era when staging a wedding in the Bay Area. Ardenwood Historic Preserve, a 205-acre working farm, captures the essence of this bygone time, making it an extremely appropriate place to tie the knot. Your guests will relish the Patterson House, a 19th-century mansion restored to perfection, which serves as the backdrop for outdoor ceremonies and receptions. Two rental options are available: the traditional Wedding Ceremony and Brunch/Lunch Reception, which takes place in the Poolside Gardens (maximum capacity of 225 guests); and the Evening Wedding and Reception, which takes place in either Poolside Gardens or the Gazebo Lawn (accommodates 220 to 700). Garden party rentals include chairs, tables, linen tablecloths for the reception only, and even setup and cleanup. If you only want to host your wedding ceremony here, the facility is available for that as well. And make sure you consider some of Ardenwood's special options, including having the bride arrive in a fairy-tale horse-drawn carriage, which will also whisk away the newlyweds post-ceremony (horse-drawn wagons are available for guest rentals, too).

Ardenwood Historic Preserve

Bancroft Hotel
2680 Bancroft Way
Berkeley
510.549.1000
Very Affordable

Once the private College Women's Club of the University of California, this impeccably maintained National Register of Historic Places landmark provides a large and versatile room for entertaining. Occupying 4,000 square feet, this area of the hotel is a fine example of restored Arts and Crafts period design, with impressive woodwork, two roomy fireplaces, stained-glass windows, and polished wood floors. You can fit a band on the room's subtle platform; the rest of the open space can be arranged in different layouts to accommodate your ceremony or reception needs (up to 250 seated or 350 standing guests). Perfect reproductions of period furniture from the hotel's heyday—it opened in 1928—can be found throughout the building.

It's located on a sunny, lively street near the University of California campus, the acclaimed University Art Museum, and shops and cafes. There's an energetic atmosphere surrounding this friendly site. Added bonuses: the Bancroft has 22 rooms available for out-of-town guests, and an event coordinator can be arranged. You can rent smaller conference rooms, should you need additional space.

Bancroft Hotel

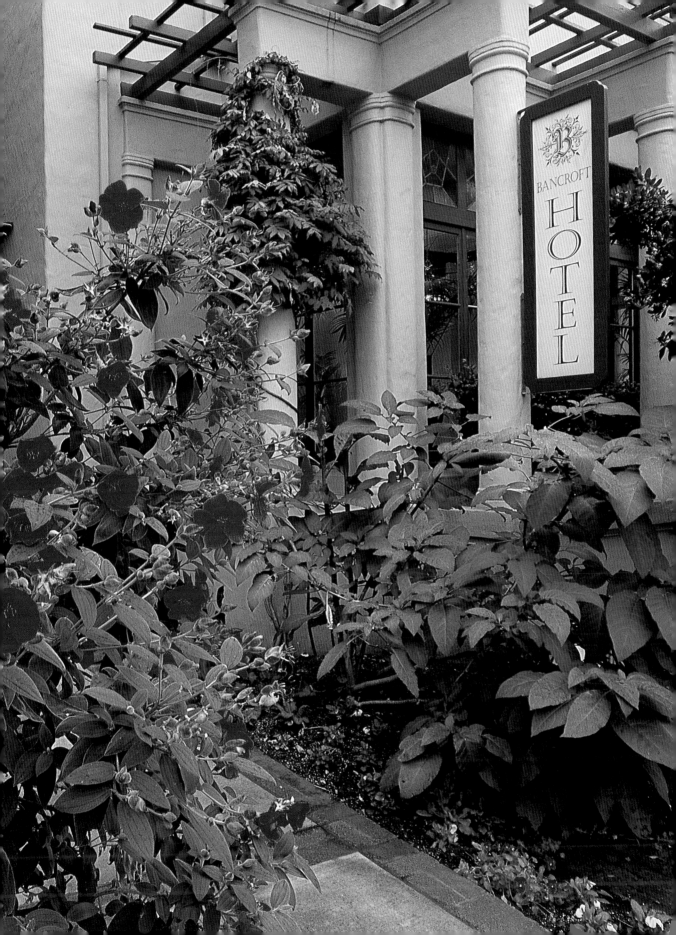

ceilings to tiled floors. Built in 1927, this tasteful, historic site has a distinctly European feel, with its carefully maintained inner courtyards and bubbling fountains. There are many areas in which to wed and celebrate (although note that weddings take place indoors only). The spacious Drawing Room, which accommodates 60 seated or 80 standing guests for a ceremony or reception, is full of adornments that remind one of a Mediterranean palace; the slightly smaller Patio Room, which accommodates 20 seated or 30 standing guests, offers similar ambience. For a wedding on a larger scale, events can be staged in the Club's Ballroom, which is reminiscent of a performance space and has parquet floors and lovely windows; the Ballroom (300 seated or 325 standing guests) can be rented along with the intimate Venetian Room, which provides a quiet spot for more personal mingling among friends and family.

Berkeley City Club
2315 Durant Avenue
Berkeley
510.848.7800
Very Affordable to Moderate

If you admire the designs of renowned interior architect Julia Morgan, who was the creative mind behind the Hearst Castle and other California landmarks, you'll appreciate the Berkeley City Club, a private club for women located near the lively University of California campus. There are plenty of ceremonial details here, from fireplaces to oriental rugs, from beamed

Berkeley City Club

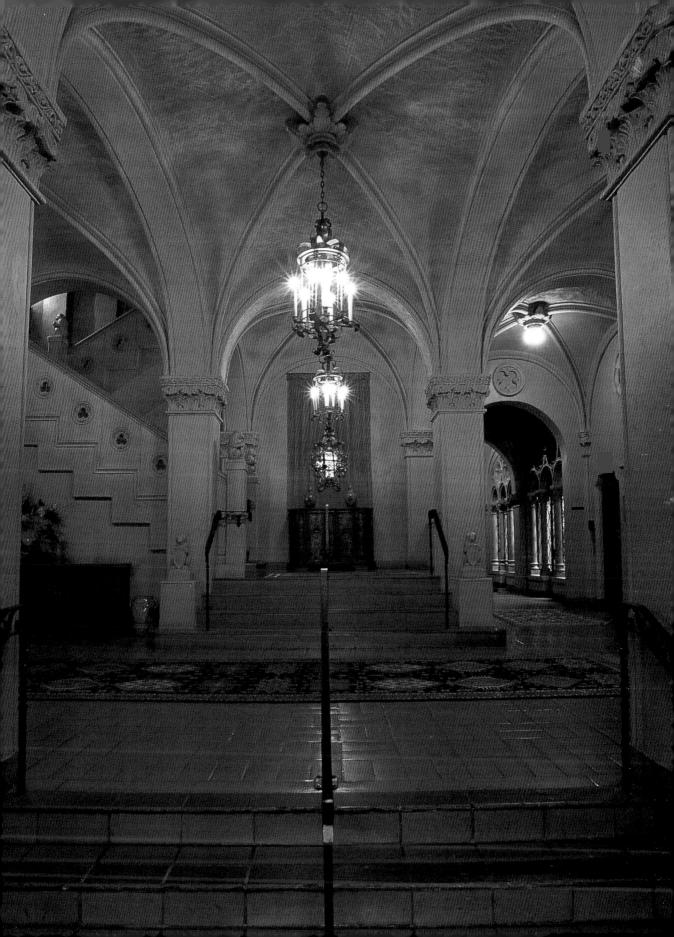

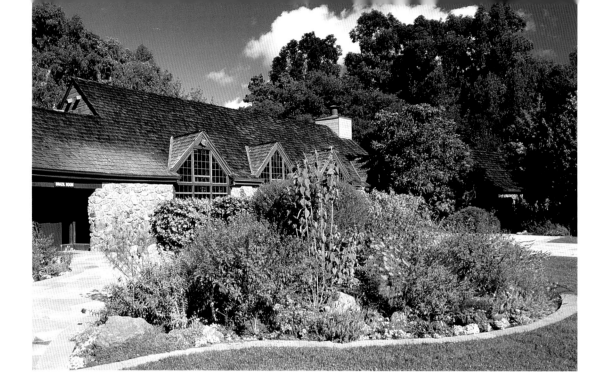

Brazil Room
Tilden Park
Wildcat Canyon and
Shasta Roads
Berkeley
510.540.0220
Very Affordable
Catering available

Surrounded by trees, lawns, and a botanical garden in scenic Tilden Park, the Brazil Room is one of the East Bay's most in-demand wedding venues.

First, though, its intriguing history. The building was a gift to the East Bay Regional Park District from Brazil, a memento of the 1939 Golden Gate Exposition, the major international event that was held on Treasure Island. The building's exterior was then rebuilt with stone and wood from the East Bay. Leaded-glass windows reach from floor to ceiling and span the length of the main room, providing natural light. Ceremonies and receptions can take place in the main room, which still features original parquet floors, wood panels, and an impressive rock fireplace. The main room accommodates 150 seated or 180 standing guests. A flagstone patio is a pleasant area for ceremonies as well. Here, up to 180 seated guests can enjoy the temperate weather, woodsy surroundings, and beautiful views of the East Bay hills.

Brazil Room

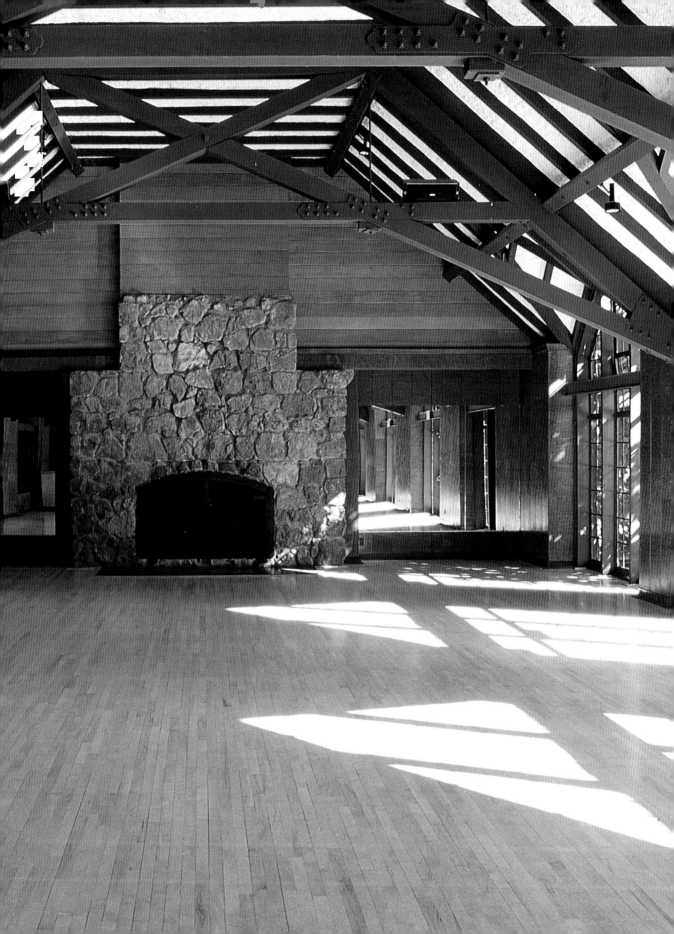

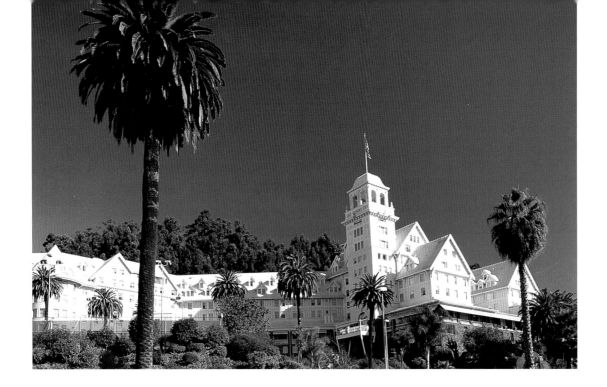

Claremont Resort and Spa
41 Tunnel Road
Berkeley
510.843.3000
Moderate to Deluxe
In-house catering
Wheelchair accessible

The gleaming white Claremont Resort and Spa is so lovely and delightful that the legendary architect Frank Lloyd Wright ranked it among his favorite places to stay. The majestic struc-ture dates back to 1915, when it was the temporary home for those visiting the Pan-Pacific Exposition in San Francisco. Local lore has it that the prime Berkeley and Oakland hills prop-erty on which the Claremont sits was the prize in what turned out to be an expensive game of checkers.

This undeniably romantic resort features a spectrum of wedding sites and amenities. Popular reception venues include the Empire, Claremont, and Sonoma Rooms, which can accommodate up to 400 guests. Your guests will have some of the best views of the Bay and its surroundings from the Claremont, which has an unrivaled hillside vantage point. Because the Claremont is a world-class spa, the food is excellent, as are the special wed-ding packages for spa treatments that include the most relaxing of massages.

Claremont Resort and Spa

Crow Canyon Country Club
711 Silver Lake Drive
Danville
510.735.8200
Moderate
In-house catering
Wheelchair accessible

Rarely will you find a scene as restful as that of the Crow Canyon Country Club, which has a private championship golf course on the grounds and the majesty of Mount Diablo as a backdrop. Weddings take place in the contemporary clubhouse. Brides generally walk down the aisle in the Jack London Lounge, which seats 150 and accommodates 200 standing guests. If you wish to book the club for a reception only, rentals include limousine service to and from a separate ceremony venue. It's that kind of attentiveness that makes this venue a top spot.

Numerous reception sites are available: the John Steinbeck Room holds up to ten seated; the Bret Harte Room and the Zane Grey Room each hold up to 40 seated, around round tables or in a U-shaped configuration; the Eugene O'Neill Room seats up to 80 or accommodates up to 100 standing guests; and the Mark Twain Room, which features a dance floor and central stage, accommodates up to 280 seated or 400 standing. The Jack London Lounge, adjacent to the Main Bar, is also available for stylish receptions.

Crow Canyon Country Club

Danville Station
1320 Van Patten
Danville
510.837.4290
Very Affordable to Moderate

Few things are more welcoming at a wedding than a sense of community; this feeling is heightened when you host a ceremony and reception for your friends and family at Danville Station, the clubhouse of the Danville Homeowners' Association. Located in one of the East Bay's prettiest neighborhoods, Danville Station displays all of the casual sophistication of the surrounding homes. Ceremonies for up to 150 seated or standing guests on the picturesque lawn, which features a grove of oak trees, feel as though they are performed at the residence of a good friend. Inside the clubhouse, which is surrounded by birch and pine trees, the same feelings of hominess and festivity are expressed in the details of the space: high, beamed ceilings, a fireplace, and two loftlike spaces for more private socializing. The capacity for indoor receptions is 60 seated or 150 standing. There's also a porch that spans the outdoor perimeter of the clubhouse, which is available for entertaining 150 seated or standing guests (this area can be combined with the indoor area as well). Your guests will enjoy the natural surroundings: a small creek, hills and valleys, and flocks of beautiful wild birds.

Danville Station

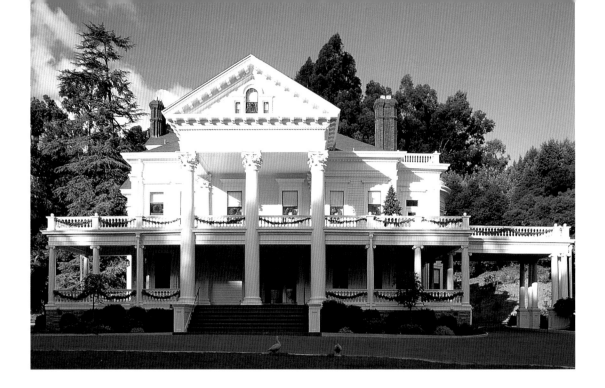

Dunsmuir House
2960 Peralta Oaks Court
Oakland
510.615.5562
Moderate

Dunsmuir House, a stately mansion dating back to 1899, is one of the world's most dramatic wedding gifts; it was given by mining fortune heir Alexander Dunsmuir to his beloved wife, Josephine, upon their marriage. This alone makes this picturesque venue a superb, year-round site for your own romantic celebration. The mansion's foyer is a lovely setting for 20 seated or 80 standing guests; Dinkelspiel House, constructed as guest quarters, provides a cozy venue for 60 seated or standing guests. For midsize, country-style ceremonies, the Carriage House accommodates 100 seated or 150 standing. And for large indoor ceremonies, the Pavilion, a room built for entertaining, accommodates 300 seated or 400 standing guests.

Surrounding the main mansion are 40 acres of lush gardens and foliage. The estate's Pond area has elm trees and a white gazebo (and the occasional swan or two) and is one of the most scenic areas to exchange vows (the Pond area can accommodate 400 seated or 75 to 400 standing guests). If you'd like to take full advantage of this extraordinary natural site, then look to the Dunsmuir House's meadows, which can accommodate up to 3,000 seated or standing guests! It's hard to match the pastoral charm of this paradise.

Dunsmuir House

Elliston Vineyards
463 Kilkare Road
Sunol
510.862.2377
Moderate
In-house catering
Wheelchair accessible

Who doesn't want to get whisked away to a fantasy setting for their wedding day? With its restful atmosphere and its timeless stone mansion, Elliston Vineyards is a calm environment that will please your senses. Built in the late 19th century with the gold rush fortune of Henry Hiram Ellis, the three-story Mansion at Elliston offers small private rooms for groups of up to 30 seated guests for dinners or ceremonies (dinners include a champagne and hors d'oeuvres greeting and a description of wines). The nearby, vault-ceilinged, 2,000-foot Terrace Room, situated among the grounds' oak trees, is the winery's entertainment center and accommodates 50 to 150 seated or standing guests for wedding ceremonies or receptions; an additional 100 guests can be accommodated if the adjoining deck—with flower gardens, gazebo, and stone terrace—is rented as well. There are many choices for outdoor ceremonies on the eight-acre lawns and gardens of Elliston Vineyards. The on-staff event coordinator can help tailor your affair. Among roses and trees, far removed from everyday life, you'll find this to be a pleasant wedding site.

Elliston Vineyards

Faculty Club
University of California,
Berkeley
510.540.5678
Very Affordable to Moderate
In-house catering
Wheelchair accessible

On this University of California campus there is a refuge known as the Faculty Glade, a quiet area of grass and oak trees. Great minds have gathered among the greenery at the Faculty Club, a California Arts and Crafts–style clubhouse nestled within the Glade. Here, professors have socialized and made merry—and so have brides and grooms and their closest friends and family. The entire club can be rented to accommodate 250 seated or 400 standing guests; this works well for hosting both ceremony and reception in one location. The club's oldest section, the Great Hall, was designed by Bernard Maybeck himself and has red-wood walls, a fireplace, and an arched ceiling. On a regular day, the Great Hall serves as the club's main dining room and site of many discussions and meetings. For weddings, this is a great ceremony or reception spot. The school's Nobel laureates are honored in the Seaborg Room, a warm environment with a fireplace and deck, looking out onto the Faculty Glade. Your guests can also enjoy the Heyns Room, which features an outdoor patio.

Faculty Club

First Unitarian Church of
Berkeley
1 Lawson Road
Kensington
510.525.0302
Very Affordable to Moderate
Wheelchair accessible

Gaze past the terrace doors of the First Unitarian Church of Berkeley (actually in nearby Kensington), and you'll witness a panorama of San Francisco, the Golden Gate Bridge, and the Marin Headlands. Located on a scenic hilltop, this modern church's Sanctuary, the most popular ceremony spot, lends a distinctly Californian flair to your event. Its unique Aeolian-Skinner pipe organ, stylish cast-iron candelabras and detailing, and wooden lectern and pulpit are decorated with lively orange accents. Up to 500 guests can be seated comfortably in the Sanctuary's wooden pews. If you prefer a smaller ceremony, the Atrium at the center of the structure seats up to 150 guests. The Atrium features a dramatic marble fountain and is a festive party spot for a postwedding party. Receptions can also take place in the Social Hall (accommodates 300), which has a stage, or in the intimate Fireside Room, which, as you might assume, has a fireplace (accommodates 100). For even cozier events, the Safir Room is pleasant for groups of up to 45 guests, the Conference Room for up to 30, and the Meditation Room for up to 25. Wedding rehearsal time is included in the fee, and the church's audiovisual equipment is available for rent. Ministerial services are available as well for a fee, even if you're not a member of the congregation (you can also bring your own officiant for a fee).

First Unitarian
Church of Berkeley

Hacienda de las Flores
2100 Donald Drive
Moraga
510.376.2521
Moderate
Wheelchair accessible

Spanish style conveys passion, and this is a perfect example. The city of Moraga owns this historic home and surrounding gardens, which provide a festive setting for a wedding. A fountain-centered courtyard patio, encircled with flowers, is a welcoming and festive sight as your guests arrive for indoor or outdoor events. Three rooms and a kitchen are available for weddings on the ground floor of the Hacienda building itself. The ground floor holds 112 seated or 150 standing guests. A fireplace and hardwood ceilings add to the traditional styling of the interior. The grounds outside the Hacienda are planted with palm trees and weeping willows and comfortably accommodate 200 guests.

Another wedding spot on the estate is the Pavilion, a classically styled structure with columns. It has one main room with an attached bar and kitchen area; this building is a semicircle portico that overlooks a patio and fully enclosed courtyard. From May through October, the Pavilion has a maximum capacity of 100 guests, seated or standing; from November through April, only the indoor area is available, accommodating 40 seated or standing.

Hacienda de las Flores

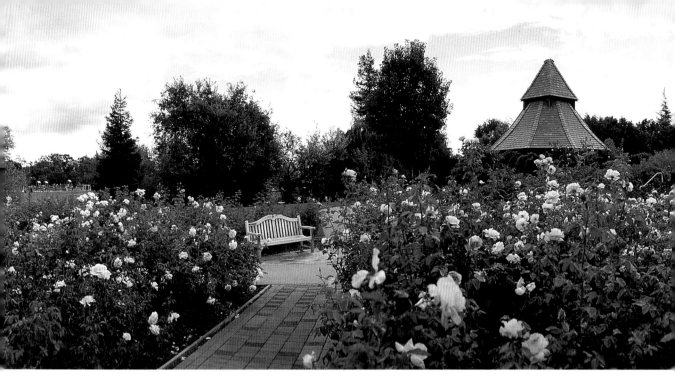

Heather Farm Garden Center
1540 Marchbanks Drive
Walnut Creek
510.947.1678
Very Affordable
Wheelchair accessible

Those in the know call it "Walnut Creek's best-kept secret." Established in 1972, the Garden Center is a nonprofit, volunteer-staffed education corporation with a mission: to share horticulture, conservation, and ecology information with the public. It's the region's very own secret garden, located high on a slope that overlooks Heather Farm Park. **I**ndoors, facilities include the Camellia Pavilion on the center's top floor; it can accommodate 300 seated guests. There's also an adjoining deck, with a glimpse of Mount Diablo, for outdoor entertaining. The Rotary Rose Room, below the Pavilion, leads to the sensory garden, where up to 300 guests can delight in the aromas of fresh lemon verbena, rosemary, and lavender.

The center has a five-acre garden, and outdoor sites include a Patio and Pavilion, which can comfortably seat 150 guests near the fragrant herb garden and fountain; the Rose Gazebo (90 guests) and Rose Gardens (just over 200 guests), where romantic roses cascade from trellises; and the Meadow Garden, an open space that accommodates up to 150 seated guests in a lawn-party atmosphere.

Heather Farm
Garden Center

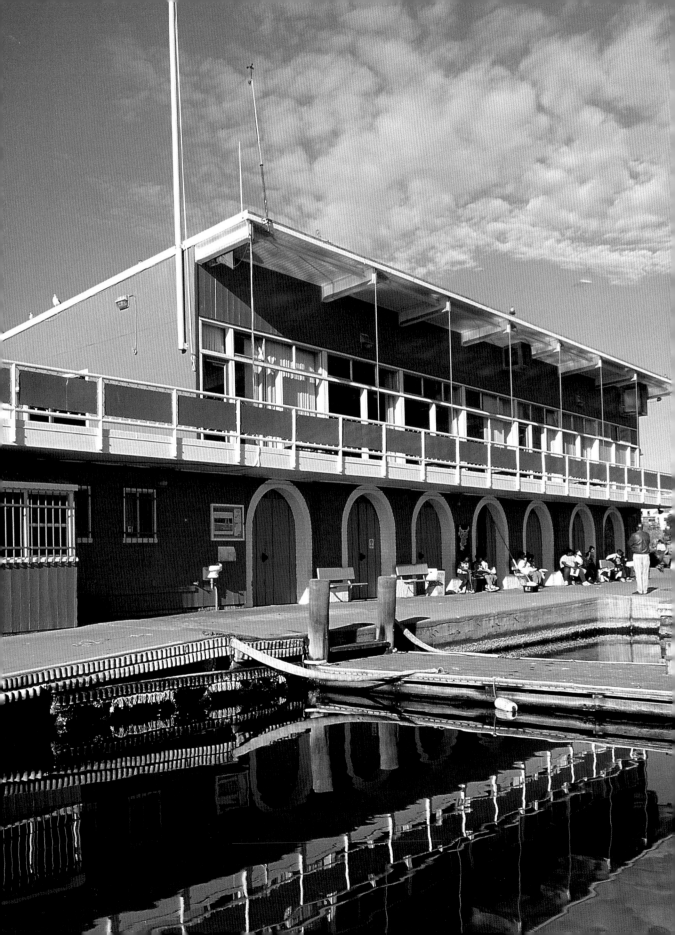

Lake Merritt Sailboat House
Lakeside Park
568 Bellevue Avenue
Oakland
510.238.3187
Very Affordable
Wheelchair accessible

One of Oakland's most scenic areas, Lakeside Park surrounding Lake Merritt is a festive setting for a wedding. The Lake Merritt Sailboat House rests right on the shores. Painted a lovely shade of blue that nearly matches the color of the sky, this structure is bordered by the grass and trees of the park. Colorful rowboats and other vessels are often docked alongside the Sailboat House; joggers and strollers circle the perimeter of the lake, enjoying the sunshine.

For ceremonies and receptions, a pretty, glass-walled main room is available, featuring a balcony that overlooks the lake. The balcony provides a great indoor/outdoor environment for everyone to enjoy on a clear day. Up to 125 seated guests or 150 standing guests can be accommodated within the structure, under a beamed ceiling. Since windows wrap around this space, your guests can enjoy sweeping views. By day, the sun streams into the Sailboat House; at night, your guests will delight in Lake Merritt's "necklace of lights"— the nickname for the sparkle provided by buildings and street-lights that line the lake.

Lake Merritt Sailboat House

Montclair Women's Club
1650 Mountain Boulevard
Oakland
510.339.1832
Very Affordable
Wheelchair accessible

For a wedding that expresses a sense of casual glamour, try the Montclair Women's Club. Initially, this clubhouse was intended to be a traditional men's club, but a community of industrious women took over when funding grew scarce. Today, it's still a women's club and a low-key yet festive setting for celebrations.

Ceremonies occur in the club's garden, which is behind the building (100 seated or standing guests). The intimate Fireside Room has a fireplace decorated with stunning Mayan tiles (25 seated or 40 standing guests). The large Main Hall, complete with stage, can fit 200 seated or 300 standing guests. Often, brides and grooms will rent the entire facility, so that they and their guests can enjoy wandering through all the rooms. Brightly painted walls and furniture add to the liveliness of your party.

Montclair Women's Club

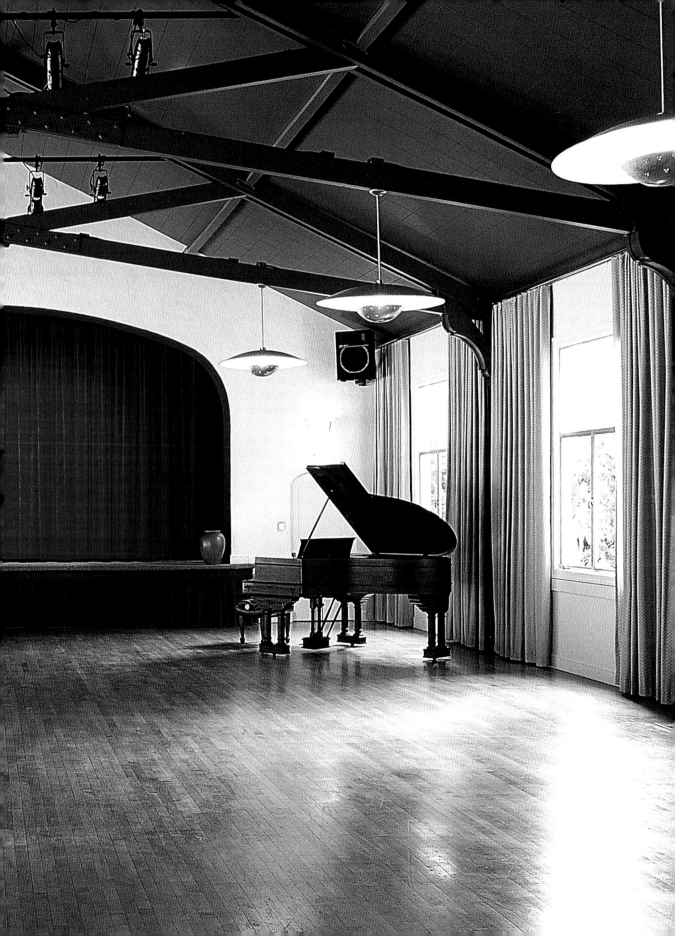

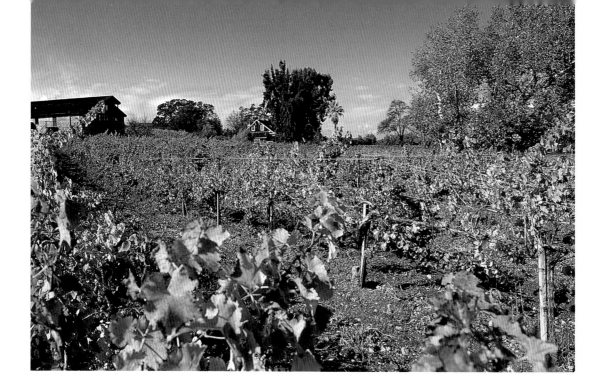

Murietta's Well
3005 Mines Road
Livermore Valley
510.449.9229
Moderate to Deluxe
In-house catering
Wheelchair accessible

Northern California is famous for its wineries, many of which can be rented for events. Murietta's Well is an endearing, historic winery nestled among rows of vines on a 90-acre estate. The main building houses antique winemaking paraphernalia and photographs from the late 19th century, adding to the sense of tradition. Past and present are both honored in the architecture, which blends polished oak floors, exposed wood beams, sparkling white walls, and some hundred-year-old concrete walls.

The winery's Balcony Room accommodates up to 125 seated guests for a ceremony and exemplifies all of the appeal of the Old World, with French doors that stretch from floor to ceiling and open onto a blossom-filled veranda. A vineyard Patio is another appropriate ceremony spot, holding 150 seated guests. Receptions are generally held in the fragrant downstairs Barrel Cellar, which accommodates 100 seated, or in both the Barrel Cellar and the Patio for a combined maximum capacity of 190 seated. Catering and service is provided exclusively by Wente Vineyards Restaurant, which recently qualified for a "Distinguished Restaurants of North America" award. Scrumptious, customized wedding cakes are also included in the menu pricing. Parking attendants and rehearsal time with an on-site wedding coordinator are supplied at no additional charge.

Murietta's Well

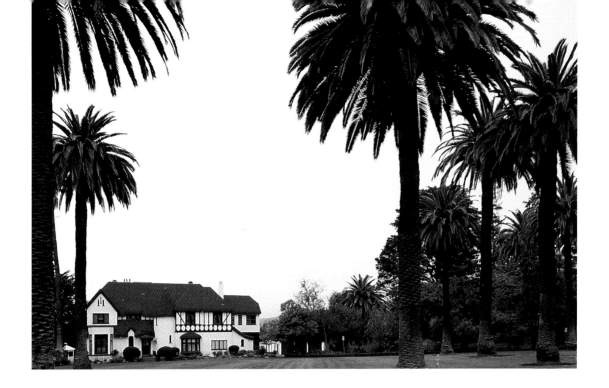

Palmdale Estates

159 Washington Boulevard

Fremont

510.462.1783

Moderate

Catering provided on

Saturdays only

Wheelchair accessible

The history of Palmdale Estates is truly unique and colorful. It was originally a part of the Old Mission San Jose garden, and its first post-Mission property administrator was Don Jose Vallejo, eldest brother of the well-known General Guadalupe Mariano Vallejo. Don Jose was famous for defending the town of Monterey against pirates; he was also a legendary *bon vivant* and shipped the first piano to the territory of Mission San Jose.

The property has changed hands several times since then, and the current white Tudor houses were built by two sisters from the Best and Starr families, for whom the homes are now named. The art deco Best House, with its foyer, ballroom, formal dining room, and marble-floored solarium, features a 2,500-foot main floor that accommodates 175 to 200 seated or 250 standing guests. Lace, velvet, and moire silk details, along with antiques, statues, and oriental rugs add to the house's elegance. Twenty-three acres of groomed, palm tree–dotted grounds surround the Best House, which can hold over 500 (though the proprietors recommend 300 guests for an indoor/ outdoor party). The Starr Gardens are also available between 10 A.M. and 6 P.M. only. Note that the fees include setup and breakdown of tables and cleanup for 200 people.

Palmdale Estates

Piedmont Community Center
711 Highland Avenue
Piedmont
510.420.3081
Moderate
Wheelchair accessible

This city-owned building was designed with impeccable taste. Popular Northern California interior and exterior elements are found here: a tiled roof reminiscent of Mediterranean architecture, redwood trees, lofty ceilings with exposed beams, chandeliers, and wood floors. And don't overlook the sweet camellias, vivid azaleas, and cherry blossoms adding vibrancy to the center's greenery during the spring and summer months. The patio accommodates 200 seated or 300 standing guests, and it is so idyllic for outdoor weddings and other celebrations that the summer slots fill fast. The facility, however, is available daily. The indoor event space boasts floor-to-ceiling windows that fill it with sunlight and offer views of the outdoors—ensuring that you and your guests will experience the beauty of the locale. The indoor space was designed for parties and events, and entertaining here feels natural and relaxed. Also note that Piedmont residents receive a lower rental rate for weddings and receptions.

Piedmont Community Center

Preservation Park
660 and 668 13th Street (at
Martin Luther King Jr. Way)
Oakland
510.874.7580
Very Affordable to Moderate
In-house catering
Wheelchair accessible

To visit Preservation Park is to visit the past in all its restored splendor. This collection of wonderful Victorian homes—along with period details such as wrought-iron fencing and antique streetlamps—is in the original town center of today's ultra-urban Oakland; in fact, five of the 16 houses were built here when this site was founded in 1853 (the remainder were moved here between 1970 and 1984). The homes are a unique, living timeline of the evolution of Bay Area housing styles, from Italianate to Queen Anne to Shingle to Craftsman. Eighty percent of the exterior details, created from virgin redwood, remain from original designs. Three areas are available for weddings. The Nile Hall, circa 1911, holds 150 seated or 200 standing and boasts a 30-foot ceiling, skylights, and floor-to-ceiling windows. The Ginn House, circa 1890, has both a large and a small parlor (combined parlors, 75 seated, 100 standing) and will remind you of an English country home. The Bandstand area, located in the center of the cul-de-sac that is Preservation Park, accommodates around 600 guests for outdoor festivities.

Preservation Park

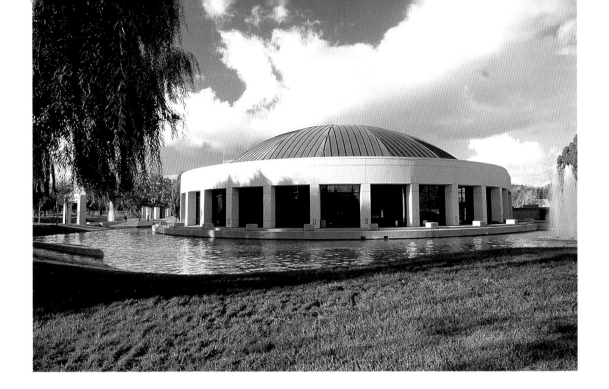

San Ramon
Community Center
12501 Alcosta Boulevard
San Ramon
510.275.2300
Very Affordable
Preferred caterers list
Wheelchair accessible

For an unpretentious wedding with an unusually stylish ambience that highlights the Bay Area's scenic beauty, try this neighborhood park center, which is surrounded by plentiful greenery and flowing water in fountains and pools. The center itself is made of stone and glass; its Terrace Room is an inviting spot for indoor ceremonies or receptions (160 seated or 200 standing guests). The Terrace Room can be combined with the art gallery, a round space that hosts monthly exhibitions, to add room for 50 standing guests (the art gallery can also be rented separately). Another prime spot for a reception is the Fountain Room, which can hold 250 seated or 500 standing guests underneath its immense 70-foot-high ceiling. Your ceremony can take place amid a multitude of roses in the outdoor gardens here (up to 140 seated guests). Whether it's a formal event or a casual affair, this setting can suit your needs.

San Ramon Community Center

Shadelands Ranch
Historical Museum
2660 Ygnacio Valley Road
Walnut Creek
510.935.7871
Very Affordable
Wheelchair accessible

Sometimes it can feel daunting to host a wedding at a historical landmark or museum, but at Shadelands, listed on the National Register of Historic Places, you'll feel at home.

Perhaps it's because much of the furniture belonged to the first owner of this 1902 Colonial Revival house, and its exterior—with a welcoming wraparound porch—is still painted its original shade of deep warm red.
Legend has it that the home was built for pioneer Hiram Penniman's unmarried daughter. His family passed down the property until they eventually bequeathed it to the city of Walnut Creek in 1970.

Events generally take place outdoors. The property has lovely lawns, rose and herb gardens, and fruit and nut trees. The charming gazebo, with its white columns, will remind guests of a wedding cake. The gazebo area accommodates 250; there is also a Victorian patio available for dancing and for standing cocktail receptions. You'll feel at ease here, and your guests will find the serenity of this outdoor setting delightful.

Shadelands Ranch
Historical Museum

Valley Oak Nursery
7021 Lone Tree Way
Brentwood
510.516.7868
Very Affordable to Moderate
Can provide catering
Wheelchair accessible

Whether you want your wedding to be a simple or a lavish occasion, the "hidden gardens" of the Valley Oak Nursery will set the proper scene. You can choose from several areas, all with commanding Mount Diablo in the background and blooming flowers, trees, and other plants surrounding you. It's an Eden-like site. A rose garden, featuring diverse breeds, greets you and your guests (this area accommodates 100, seated or standing). The manicured grounds include a wisteria-covered gazebo and an outdoor amphitheater (400 seated guests). The amphitheater is next to a courtyard patio that's appropriate for a reception.

An especially tranquil spot in which to make your vows is at the end of winding brick pathways. Here you'll find a clear, sparkling koi fishpond with an arched bridge. This peaceful area can accommodate 400 seated or standing guests.

Valley Oak Nursery

Campbell Hall and Garden

China Cabin

Corinthian Yacht Club

Falkirk Mansion

Headlands Center for the Arts

Lark Creek Inn

Marin Art & Garden Center

Marin County Civic Center

Mill Valley Outdoor Art Club

Old St. Hilary's

Point Reyes Seashore Lodge

Rock Ridge Gardens

north bay

Campbell Hall and Garden
San Carlos and Santa Rosa
Avenues
Sausalito
415.332.0858
Very Affordable

The quaint bayside town of Sausalito is known not only for its views of the San Francisco Bay and the glittering City but also for its warm sense of laid-back comfort. Tucked away in the hills of Sausalito is this community center, a hidden jewel of a wedding site.

The unassuming exterior appears to be, upon first glance, another one of Sausalito's woodsy dwellings. But the complex is distinguished by the sun-filled Main Reception Room (140 seated or 250 standing guests), located on the top level of the hall. If you require more space, there's an adjoining terrace that accommodates 40 additional guests.

Downstairs, the cozy Garden Room (which can be rented in conjunction with the Main Reception Room) holds 30 to 35 seated or 55 standing guests. The Garden Room opens onto an outdoor garden from which you can catch a glimpse of the deep blue ocean between the surrounding trees.

Campbell Hall and Garden

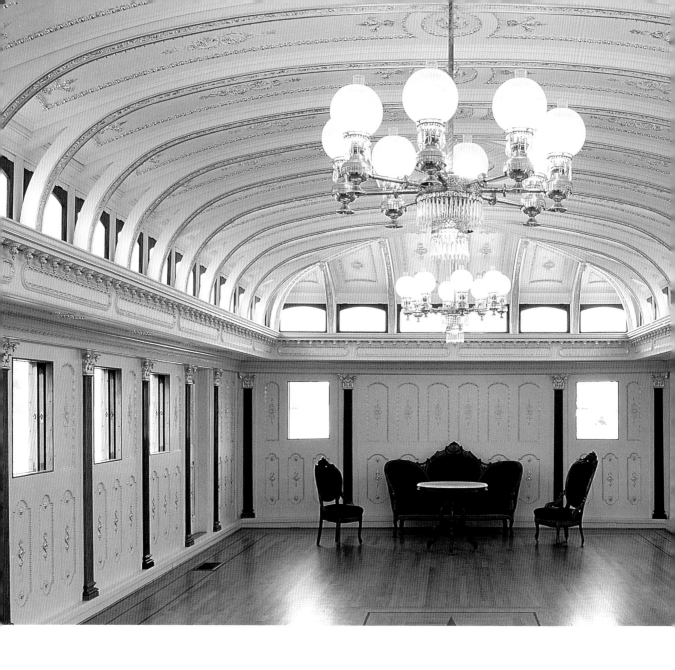

China Cabin
54 Beach Road
Belvedere
415.435.1853
Very Affordable
Must be approved caterer
Wheelchair accessible

You want a small wedding, but you don't want to sacrifice the style or sense of taste that accompany large, ornate spaces. China Cabin, a waterfront landmark, is as impressive as larger venues, yet it's just right for ceremonies of 40 to 50 guests; for receptions, it accommodates 50 to 65.

What makes China Cabin so distinctive? First, there's the peerless locale, Belvedere Cove, from which you can see not only the skyline of San Francisco but also vessels docked at the nearby yacht harbor. Second, there's the quirky history. Originally, China Cabin was the social area for first-class passengers on an 1866 sidewheel steamship. Unfortunately, the steamer had a weak wooden hull and was burned for scrap metal. China Cabin, however, was so grand that it was preserved, and it stands today as one of the most dignified smaller-scale sites for a wedding.

The architectural details are magnificent—the two staterooms and the main room exhibit intricate wall carvings, sumptuous crystal chandeliers, and glass windows bearing meticulous etched designs. The outdoor deck, which frame three sides of the structure, lets you dine and celebrate under the stars.

China Cabin

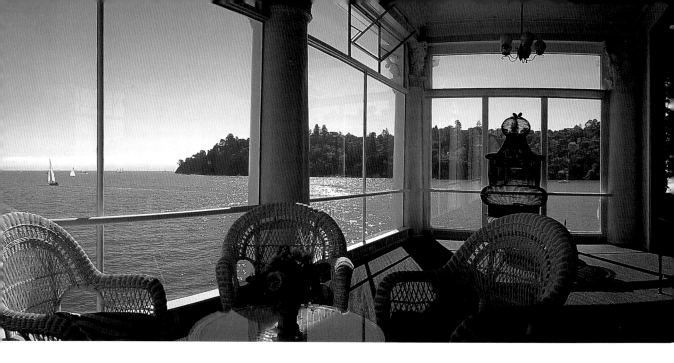

Corinthian Yacht Club
43 Main Street
Tiburon
415.435.4812
Moderate
In-house catering
Wheelchair accessible

The gleaming white exterior, columns, and widow's walk of the Colonial Revival–style Corinthian Yacht Club resemble the loveliness of a wedding cake. This, plus its gorgeous locale near Tiburon, right at the shore of the shimmering Bay, makes the Corinthian Yacht Club an excellent choice for a romantic celebration.

Rich in history, the club was founded in 1886 by a community of daring young yachtsmen; in fact, it's the second oldest yacht club on the West Coast. Its prime location offers an unparalleled vista of the San Francisco Bay, Angel Island, Treasure Island, Alcatraz Island, and the San Francisco skyline. The ferry landing is nearby, so guests arriving from San Francisco have only a short stroll to the club's front door.

The club's Ballroom holds up to 250 seated and 400 standing guests. The club's Dining Room is available from Monday through Thursday; it accommodates 100 seated or 150 standing guests. For your reception, there's a selection of impressive menus available, representing French, Italian, Greek, and California cuisines.

Corinthian Yacht Club

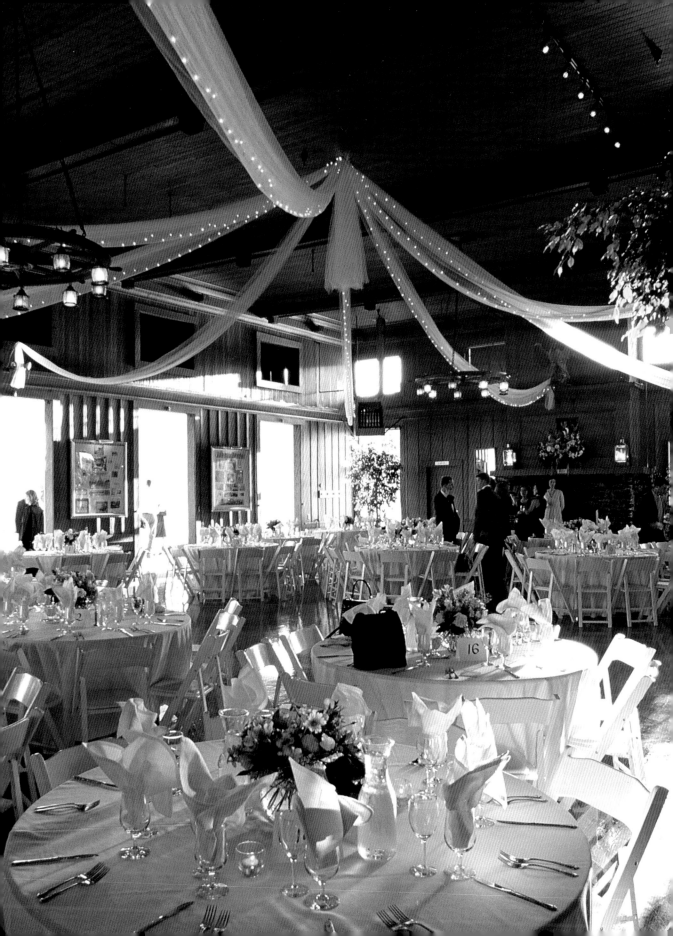

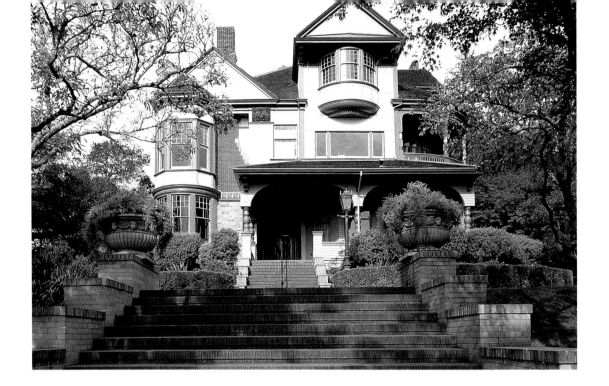

Falkirk Mansion
1408 Mission Avenue
San Rafael
415 485.3328
Moderate
Preferred caterers list
Wheelchair accessible

Because it's a cultural center housing contemporary art and arts education programs by day, the Falkirk Mansion is naturally aesthetically pleasing. The building has bay windows, brick chimneys, gables, hardwood floors, fireplaces, redwood paneling, and a veranda; outside are lush lawns, oak and magnolia trees, and camellias. The entire site is picture-perfect for weddings. The mansion was designed by the same architect who created the stately chapel of Stanford University and was built in 1888 with later additions by the second owner, Captain Robert Dollar.

Ceremonies take place in the parlor, which seats 50 or accommodates 75 standing guests. Outdoors on the lawn, 125 seated guests are comfortable. Receptions usually take place inside the mansion. The site's winter capacity is 50 to 60 seated or 85 standing guests; brides and grooms rent the entire first floor, which includes the parlors and the notable dining room, with its stained-glass windows. In the summer months, the veranda is also used for receptions, which increases capacity to 125 seated or standing guests. This location has an air of comfort and a characteristically Bay Area Victorian style.

Falkirk Mansion

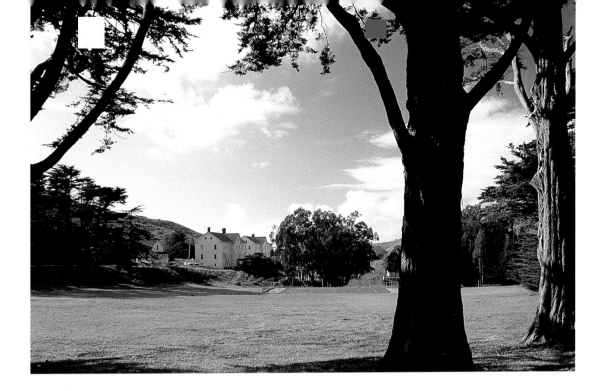

Headlands Center for the Arts
Golden Gate National
Recreation Area
Office: 944 Fort Barry,
Sausalito
415.331.2787
Moderate
Can provide list of caterers
Wheelchair accessible

The Golden Gate National Recreation Area includes the rolling hills of the Marin Headlands, near the Pacific. Within this park is the Headlands Center for the Arts, a nonprofit organization that attracts artists and intellectuals from around the globe. Housed in 11 historic military buildings among 12,000 acres of coastal open space, the center is one of the most inspirational environments for artists in the nation. It can inspire great weddings as well—weddings that embody a relaxed aesthetic. Ceremonies and receptions can take place in the second-floor rooms of Building 944, the center's headquarters and a former Army barrack dating back to 1907 (capacity is calculated for individual events). The rooms have the airy feel of a gallery; in fact, many artists-in-residence at the center have supervised the renovations of these rooms over the years. On the floor below is the center's Mess Hall, a quaint reception site for approximately 125 seated guests, with its open kitchen, mismatched chairs, and inspired wall decorations by some of the center's artists-in-residence.

Headlands Center for the Arts

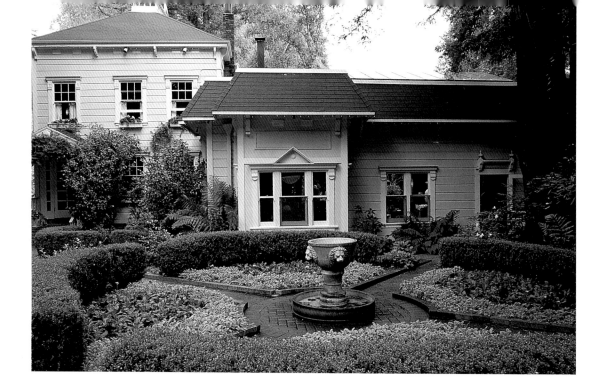

Lark Creek Inn
234 Magnolia Avenue
Larkspur
415.924.1602
Moderate
In-house catering
Wheelchair accessible

For a pastoral daytime wedding with a lot of flair, try the Lark Creek Inn. One of the best-loved restaurants in the Bay Area, it's also a favorite of food critics nationwide. The physical charm of this venue makes for fond memories. The inn is actually a Victorian country house that was built in 1888; a gentle creek and stately redwood trees round out the scene. An on-staff wedding coordinator can help you with your ceremony and reception, which can occur only on a Saturday between 11 A.M. and 4 P.M. Indoor receptions take place in the entire restaurant, which accommodates 100 seated or 250 standing guests. Outdoor ceremonies take place on a patio, which accommodates 60 seated or 100 standing guests. Packages include reception catering featuring the best regional produce in the region (mostly local growers who exclusively supply the Lark Creek Inn); all-American buffet luncheons, with an emphasis on salads, fish, and poultry; or formal seated luncheons. Keep in mind, though, that the cordial staff invites active participation in formulating the perfect menu for your own unique wedding.

Lark Creek Inn

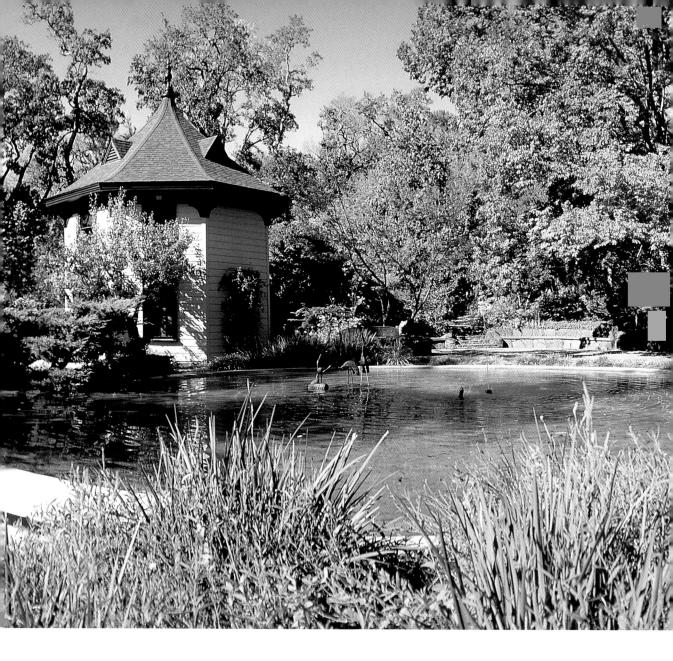

Marin Art & Garden Center
30 Sir Francis Drake Boulevard
Ross
415.454.1301
Moderate
Wheelchair accessible

The radiance of the North Bay is evident at the ten-plus-acre Marin Art & Garden Center, located in Ross, one of the area's most upscale neighborhoods. The Art & Garden Center includes the Stratford Gardens, which bloom with flowers and are delicately shaded by canopies of oak trees and English Elms. The center also includes the secluded Caroline Livermore Room, a casual space that features a large fieldstone fireplace. Here, you and your guests can enjoy views of the perfectly maintained gardens through large sliding glass doors; this venue is available year-round and can accommodate up to 120 seated guests. From spring through fall, you can rent the Livermore Room and the Stratford Gardens together to accommodate a guest list of up to 300.

There are many other sites at the center that can be rented along with the Caroline Livermore Room for a small additional fee; these are subject to availability. Sites include the Fountain Garden, the Magnolia Tree Lawn, the Meadow Lawn, the Sequoia Tree Garden, the Memory Garden, and the Garden House. All areas are wonderful for ceremonies and receptions.

Marin Art & Garden Center

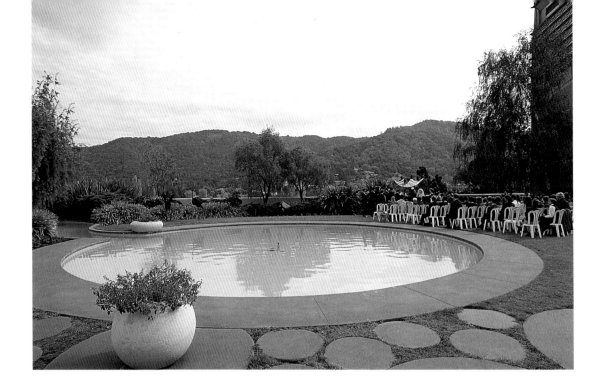

Marin County Civic Center
Civic Center Drive at North
San Pedro Road
San Rafael
415.499.6387
Moderate
Wheelchair accessible
Call for catering options

This masterpiece by Frank Lloyd Wright has recently opened its doors to weddings. A National Historic Landmark, it has been featured in books and documentary films about Wright's most notable work, and it is the only government building he designed. The structure features clean architectural lines and stylish details such as unique, scalloped ceiling borders.

The Cafe, located on the second floor of the building, is a flexible event space that accommodates 330 seated or standing guests, and it features a sturdy floor perfect for dancing. The Cafe opens onto a stunning patio that holds 90 seated or 200 standing guests. From here there are panoramic views of Marin County's rolling hills. A dramatic, towering spire and a fountain—both of which are lit theatrically for night weddings—decorate the space.

Also available is the outdoor deck of the Board of Supervisors Chambers on the center's third floor, accommodating up to 200 standing guests and with equally sweeping vistas.

Marin County
Civic Center

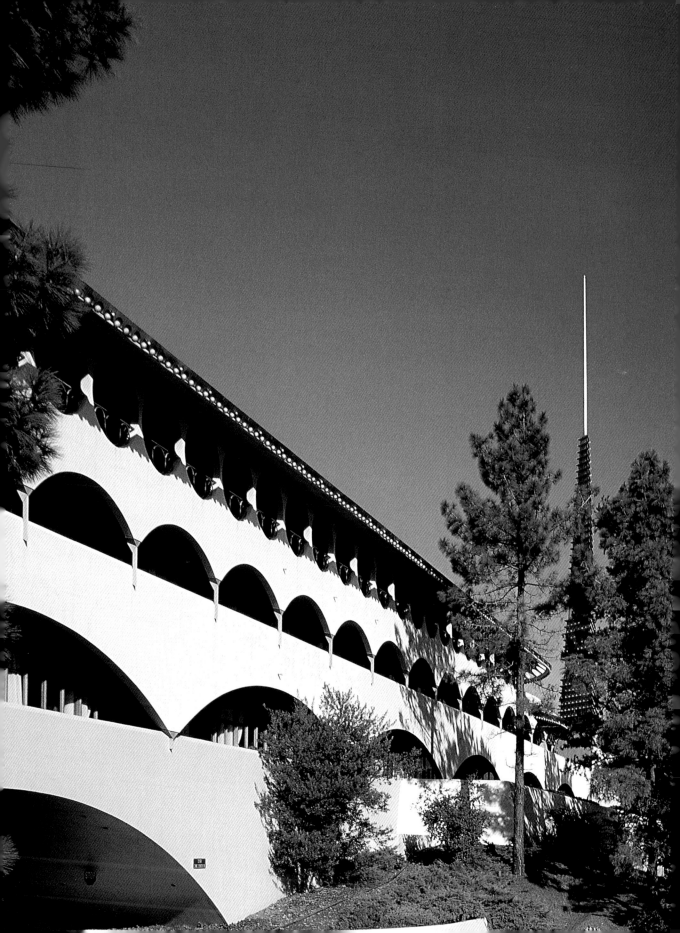

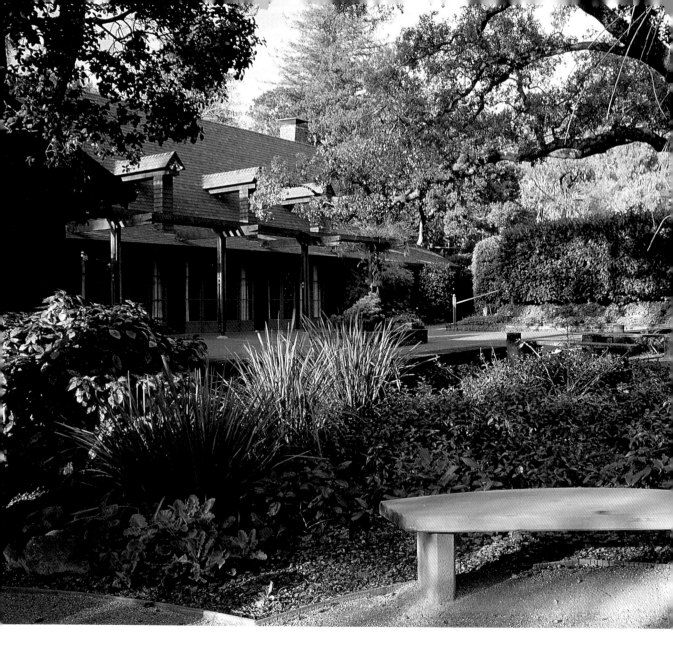

Mill Valley Outdoor Art Club
1 West Blithedale Avenue
Mill Valley
415.383.2582
Moderate
Wheelchair accessible

When the Outdoor Art Club was organized in 1902, its founder, Mrs. Lovell White, established its objective: to beautify Mill Valley. An attractive community, Mill Valley has definitely been beautified by the trees and flowers planted by the Outdoor Art Club, which boasts a clubhouse designed in 1904 by Bernard Maybeck himself.

The building, rich with country charm, is a timeless example of the Arts and Crafts architecture that made Maybeck famous. The Main Hall has chocolate-colored shingles and French doors on the outside and hardwood floors and high ceilings on the inside; it accommodates 120 seated or 200 standing guests. The smaller Sun Room, alongside the Main Hall, provides room for 40 seated guests. Outdoors, the patio, which is also connected to the Main Hall, is surrounded by blooming flowers and greenery. The garden features an elegant oak tree and is a pretty spot for 150 seated or 200 standing guests to mingle. Another area, the small wedding garden, holds 80 seated or 150 standing. Amenities include tables, chairs, place settings, bar areas, and garden umbrellas, as well as an upright piano.

Mill Valley
Outdoor Art Club

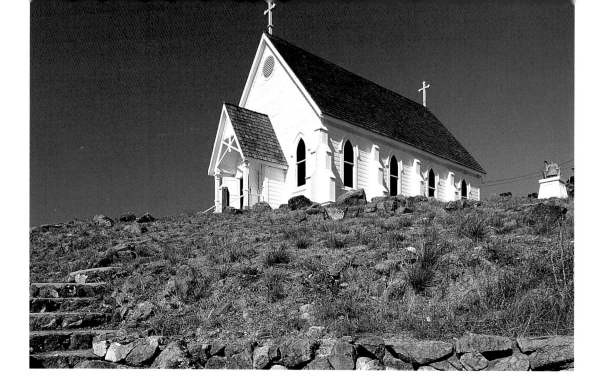

Old St. Hilary's
Esperanza Street via Beach
Road
Tiburon
415.435.1853
Very Affordable
Wheelchair accessible

This mission church, with redwood walls and a Douglas fir ceiling, is a rare surviving example of Carpenter Gothic architecture. Built in 1888 to meet the spiritual needs of the budding community of Tiburon (which was established as the railroad system expanded), Old St. Hilary's is a notable area landmark. The window above the door is original; it illustrates St. Hilary, the patron saint of scholars, for whom the building is named. The chandeliers, now electronic, are replicas of those that first lit the church, which were suspended by ropes. The original furnishings remain as well: two pews, the white altar railing, two white pedestals for statues, and the concert grand piano. In fact, Old St. Hilary's is situated in a wildflower preserve that was proclaimed by a well-known botanist to be "one of the most interesting and remarkable and beautiful wildflower gardens in California (and therefore the world!)." There are 217 species of ferns and seed-bearing plants, many of which are rare and endangered. The total capacity for ceremonies and receptions at this quiet site is 125 seated or standing guests.

Old St. Hilary's

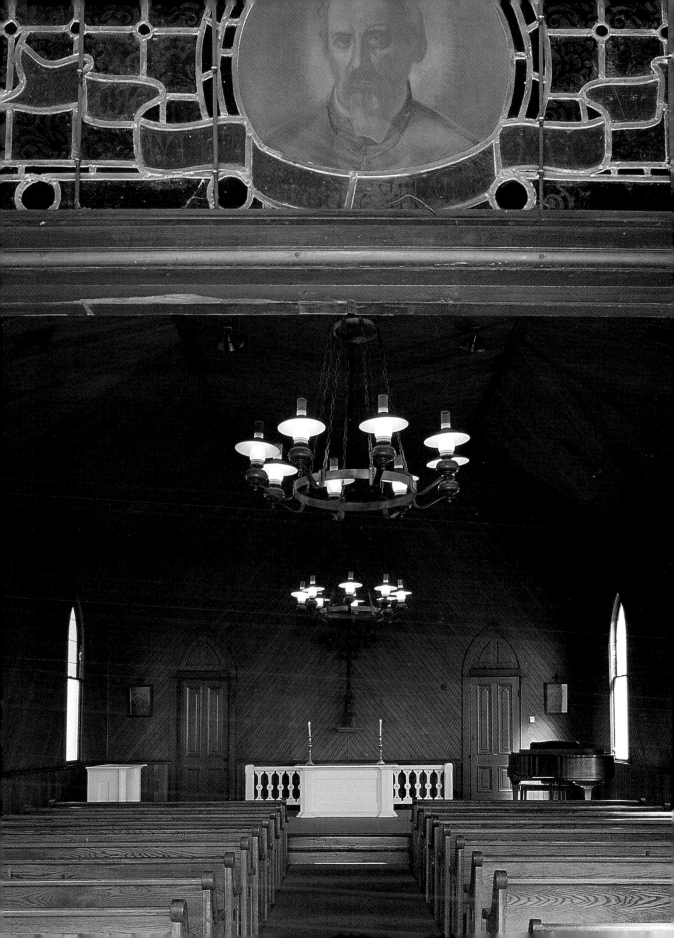

Point Reyes Seashore Lodge
10021 Highway 1
Olema
415.663.9000
Moderate to Deluxe
Preferred caterers list
Limited wheelchair access

If you're familiar with the Point Reyes area of Northern California, you know that it possesses a rare beauty. The 21-room "eclectic Victorian" Point Reyes Seashore Lodge was built almost entirely from plentiful local wood; its two acres of grounds are filled with oak, olive, and pine trees. Adjoining the lodge is the immaculately restored 1858 Casa Olema retreat, and nearby are redwood groves and the Point Reyes Seashore National Park.

Should you wish to wed outdoors, you couldn't ask for a better spot: behind the lodge is a lawn that blooms with camellias and other native plants and leads to a meandering creek. Winding paths connect the lodge to Casa Olema, which offers an eight-person spa on the rear deck as well as an attractive lawn for parties. Casa Olema's lawn and the lawn behind the lodge can each accommodate up to 150 guests, seated or standing. There is also ample parking at this site, and rooms can be booked for wedding guests. (The lodgekeepers can also introduce you to local vendors.)

Point Reyes Seashore Lodge

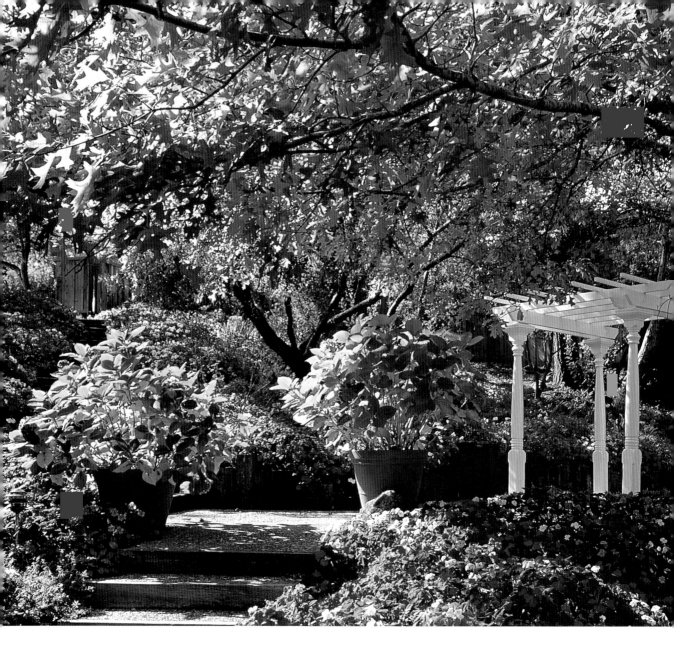

Rock Ridge Gardens
44 Rock Ridge Road
Woodacre
415.924.3900, 415.488.4358
Very Affordable to Moderate
Must approve caterer

This is a lovely spot for a country wedding. The colorful and lush foliage at Rock Ridge Gardens is an excellent backdrop for exclusively outdoor events. Thousands of brightly hued flowers grow alongside a staircase that is gently shaded by oak and fir trees. A slope leads to a garden and an emerald green lawn bordered by fruit-bearing trees. There is a delicately romantic white wooden trellis and accompanying platform on the lawn; the platform accommodates 12 to 14 wedding participants only. Tables, chairs, and a buffet table can be set up in this area (which accommodates 150 seated guests); dancing can take place on a paved area nearby. The gardens are located at the modern cedar home of a hospitable couple, the Browns, who are careful to make you and your guests feel comfortable in this private yet distinctly celebratory environment. The Browns open up their house to brides, letting them use it as a dressing room for the big event; the couple is also available to contribute their experience as restaurateurs to your wedding planning process.

Rock Ridge Gardens

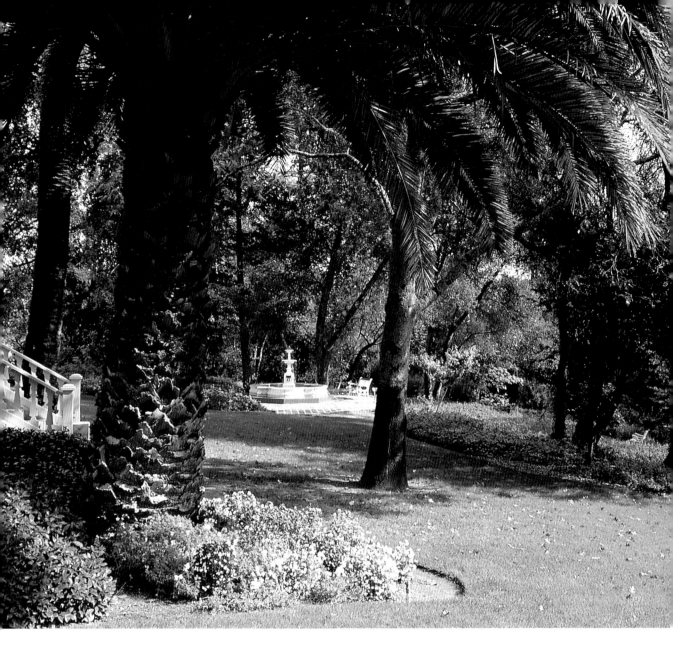

wine country

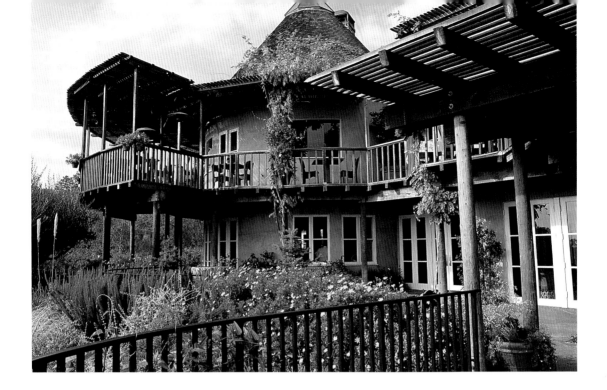

Auberge du Soleil
180 Rutherford Hill Road
Rutherford
707.963.1211
Moderate to Deluxe
In-house catering
Wheelchair accessible

For a wedding that celebrates the one-of-a-kind Napa Valley aesthetic with panache, this stylish spa and restaurant provides a lovely backdrop. A renowned getaway, Auberge du Soleil is located in a secluded, 33-acre olive grove, bounded by sun-dappled vine-yards. The region's signature Mediterranean style prevails in the architecture and decor, with the subtle elegance of earth tones, terra-cotta tiles, and natural wood. The sharing of vows takes place on a special ceremony deck on the sunny terrace, which offers views of the surrounding area and its blooming wisteria, trees, and grapevines. With its stone-sculpted fountain, the ter-race can serve as a warm site for a small reception (up to 75). All interior spaces open to the terrace through French doors.

Indoors, the Cedar Room fea-tures a century-old cedar trunk as well as a cozy fireplace; it accom-modates 40 seated, 75 standing guests. Larger dinners of up to 150 seated can be accommodated in the Vista I room; the Vista II seats an additional 75. The staff recommends that all three indoor spaces be rented for weddings of over 50 guests, for mobility and full access to both inside and outside. (There is no fee for ceremonies if an indoor room is rented.) Auberge du Soleil offers first-rate cuisine as well.

Auberge du Soleil

B. R. Cohn Winery
15140 Sonoma Highway
Glen Ellen
800.330.4064
Deluxe
Can provide list of caterers
Wheelchair accessible

This glorious 60-acre winery is a dreamlike setting for a wedding. The very first couple to be wed here took full advantage of the country glamour of this site by riding around the grounds in a horse-drawn carriage. Now you, too, can celebrate your wedding among the winery's olive and oak trees. Extraordinary outdoor ceremonies occur in either the Theater in the Vines, which features a stage and holds 175 seated or 225 standing guests; the Olive Grove, which seats 200 or holds 275 standing guests; or the Terrace of the winery's tasting room, which seats 175 or hosts 275 standing guests. Of course, these venues all make stunning backdrops for receptions as well (with the same maximum capacities); other arrangements can also be made with the staff's event coordinator. This outstanding locale showcases the elegance that makes the California wine country one of the world's most popular destinations.

B. R. Cohn Winery

Beltane Ranch
11775 Sonoma Way
Glen Ellen
707.996.6501
Moderate
Preferred caterers list
Limited wheelchair
accessibility

This charming site is only available for weddings between the months of April and October for a good reason: quite simply, spring and summer events are spectacular here. Grapes are grown for the well-respected Kenwood Vineyards at the Beltane Ranch, which has been owned by the same family since the 1930s. The Ranch includes a bed-and-breakfast, which has five rooms that can all be rented for two nights for a reasonable flat rate to accommodate your wedding guests. Recently, the Ranch and its cozy B & B have been featured in *Travel and Leisure* and *The Wine Spectator* magazines.

Since the Beltane Ranch has a large lawn area that looks out onto a picturesque valley, outdoor weddings for up to 300 seated or standing guests can take place at a variety of areas on this property. The garden area is a popular spot; you'll find finely crafted redwood tables that are so pretty no linens are required. Small wedding celebrations can also take place under the B & B's awning. An "aisle" down which the bride and her attendants can promenade can be set up facing the B & B as well.

Two advantages to hosting a wedding at the Beltane Ranch: wedding rentals ensure exclusive use of the site; and chairs, setup, and takedown are included in the rental fee.

Beltane Ranch

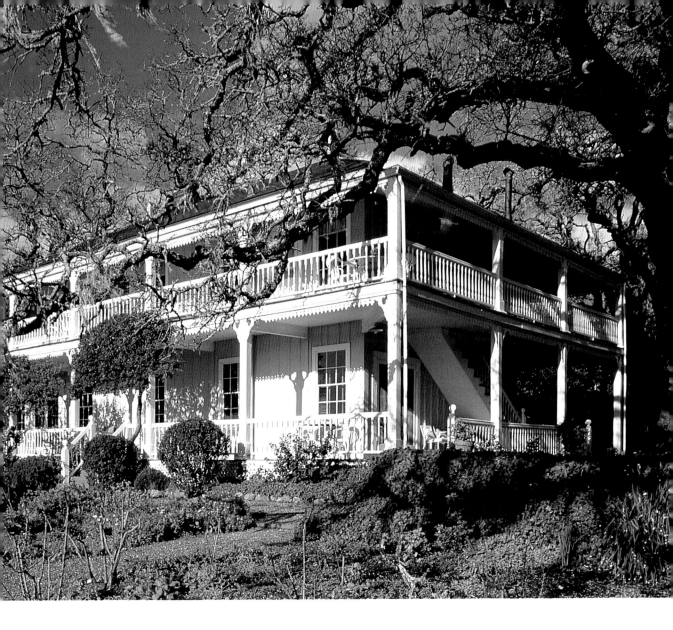

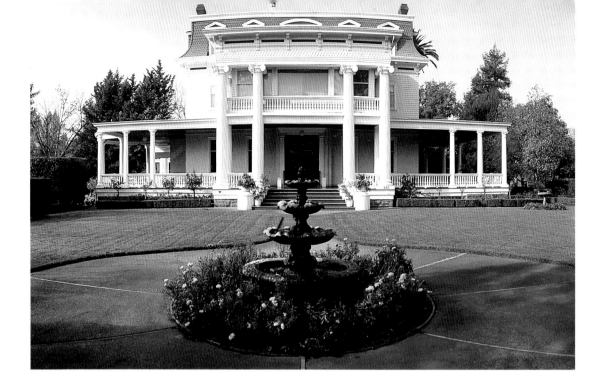

Churchill Manor

488 Brown Street

Napa

707.253.7733

Moderate

In-house catering

Limited wheelchair access

Be a part of Napa tradition by tying the knot at Churchill Manor, which has been hosting fine weddings for more than a century. The manor's dignified columns and manicured gardens greet you first, and inside it has antiques, ornate woodwork, a large fireplace, opulent ceiling ornamentation, and brass and crystal details that date back to the late 1880s, when the manor was built. The parlor is a lovely room for small ceremonies or receptions, accommodating 50 seated or 70 standing; the rotunda can host up to 125 seated guests for ceremonies. The lawn, sprouting here and there with flowers, is a wonderful setting for an outdoor ceremony, during the summer accommodating up to 150 guests. In the slightly cooler months of spring and fall, the manor's veranda is a pleasant place for receptions of up to 125. In the summer, combine the garden and veranda to host a ceremony and reception for up to 150 guests. Churchill Manor is now an inn, and you can reserve the entire building, ten guest rooms, for your wedding party. The enthusiastic and seasoned wedding coordinators can also arrange wine country tours and activities.

Churchill Manor

Garden Valley Ranch

498 Pepper Road

Petaluma

707.795.0919

Moderate

In-house catering

Wheelchair accessible

Ah, the sensual delight of a one-acre fragrance garden and 8,000 rosebushes! These are two of the perks of hosting a wedding at Garden Valley Ranch, an eight-acre working ranch established in 1981 to cultivate roses for the floral industry. The ranch's founder, Rayford Reddell, is a well-known writer and rosarian, and the ranch's luscious roses have drawn worldwide praise. From mid-April to October, you'll find the roses in bloom and the site available for weddings. In addition to the fields of glorious flowers, a Victorian belvedere—a 18-foot-by-20-foot brick dance floor set in a giant lawn—is available for your celebration. Tents or canopies can be set up on the 5,000-square-foot lawn; the entire facility can accommodate up to 200 guests. Amenities include a changing room for the bride, restrooms near the festivity sites, and an area for designated parking. Of course, the ranch has experienced floral designers on staff. A kitchen facility is available for use only by the ranch's exclusive caterer, Dempsey's. Catering costs include linens, table settings, glassware, service, and your choice of menus. In addition, an event coordinator will help you on the day of your wedding.

Garden Valley Ranch

Healdsburg Country Gardens
670 Bailhache Avenue
Healdsburg
707.431.8630
Moderate
Wheelchair accessible

Do you picture your guests relaxing among lilacs and wisteria, vineyards and orchards, raising a glass to toast your wedding at a beautifully rural spot? This 15-acre farm provides such surroundings. There are many pretty places for sunny outdoor ceremonies for up to 150 onlookers. What better canopy could you have than the outstretched branches of the trees? Is there more appropriate wedding decor than roses exploding with color? Is there a more festive sight than a terrace covered with grapevines?

If you have a small group of friends and family gathering for the ceremony, the deck of the farmhouse, along with its lawn, accommodates 35 seated guests nicely. Also, don't overlook the redwood barn; it holds a great dancing spot for your reception. The barn can be rented along with the terrace, the lawns, and the flower gardens for a wedding event that brings this quaint setting to life. Healdsburg Country Gardens also offers three guest rooms for overnight stays—a wonderful reprieve after a joyous day.

Healdsburg
Country Gardens

Madrona Manor
1001 Westside Road
Healdsburg
800.258.4003
Moderate
In-house catering
Wheelchair accessible

There are many beautiful Victorian homes in the San Francisco Bay Area, but few have the appeal of Madrona Manor. Situated in a very quiet area, Madrona Manor claims eight green acres as its grounds. It was built in 1881 by San Francisco businessman John Paxton as his country house, and he returned to this site over and over again. A sense of refinement pervades the manor's interior. Its antiques and architectural details lend it a tasteful opulence. Smaller ceremonies of 35 to 40 seated or 60 to 70 standing guests work well here. Because Madrona Manor's exterior is so exceptional, outdoor weddings on the terrace are a natural choice. If you've got 130 seated or 150 standing guests on your list, they will find this setting full of pastoral pleasures: green fields of grass, many colorful flowers, and vegetable and herb gardens. Renting the full complex, including the Carriage House (pictured above), allows guests to enjoy all of the manor's ambience.

The manor is also known for its fine dining, and catering is provided. Rental fees include one guest room for two nights, so you can relax and soak up the charm of the manor before and after your celebration.

Madrona Manor

Meadowood Resort
900 Meadowood Lane
St. Helena
707.963.3646
Moderate to Deluxe
In-house catering
Wheelchair accessible

Situated on 250 acres in Napa Valley, the Meadowood Resort is a marvelously romantic wedding site. The gabled roofs bring to mind traditional East Coast homes. In the giant main clubhouse is the Vintner Room, which accommodates 110 seated guests for indoor receptions and is complete with lofty ceilings, a view to die for, and the warmth of a fireplace. The Vintner Room can be combined with its adjoining lawn area to accommodate 140 additional guests. Also indoors is the Woodside Room, which seats 60 (or up to 80 if its accompanying outdoor area is also used). The Vintner Glen can be used for an al fresco ceremony, accommodating from 250 to 300 seated and 300 to 350 standing guests. The Woodside Lawn is perfect for seating 60 to 80 guests to witness an outdoor exchange of vows, with standing capacity of 80 to 100. A pleasant Croquet Glen is also available for outdoor ceremonies; it seats 100 guests or provides room for 150 standing guests.

Meadowood Resort

Sonoma Mission Inn & Spa
Highway 12 and Boyes
Boulevard
Sonoma
707.938.9000
Moderate to Deluxe
In-house catering
Wheelchair accessible

In the heart of California's Wine Country, the grounds of the acclaimed Sonoma Mission Inn & Spa occupy ten secluded acres of century-old eucalyptus trees and colorfully hued gardens. The inn is a stunning example of mission-style architecture, and its signature rose exterior is a landmark, standing out in an area of abundant natural beauty.

It's no wonder that the Sonoma Mission Inn & Spa is known worldwide as an exceptional place to relax and retreat, and it's a truly peaceful site for a happy celebration. The resort, rated as "Four Star" and "Four Diamond," has numerous options for ceremonies and receptions. The Sonoma Valley Room accommodates 150 seated or 250 standing guests (and a dance floor at no additional charge). The Tent, which includes use of the Sonoma Valley Room for dancing, seats up to 350 guests. And if a Sunday wedding is right for you, the following is complimentary: a champagne toast, wedding cake, use of the Wine Country Room (with its cozy fireplace), spa access for the bride and groom, and special room rates for family and friends. The resort's inspired Wine Country menu is nationally acclaimed (and don't forget a wine list of premium Sonoma and Napa wines); you can be sure your guests will delight in the in-house caterer's cuisine.

Sonoma Mission Inn & Spa

Villa Chanticleer
1248 North Fitch Mountain
Road
Healdsburg
707.431.3301
Very Affordable to Moderate
Preferred list of caterers
Wheelchair accessible

Northern California is well known for its redwoods and its wines. You can find both at the Villa Chanticleer, a woodsy retreat in the center of glorious Wine Country. The villa's history began in 1910, when San Francisco's elite gathered there as a getaway from the city. Up to 200 people at a time would ride up slopes in their horse-drawn buggies to the villa, then an exclusive vacation resort. Legend has it that the villa fell into the hands of gangsters in the tumultuous 1940s; after a serious fire and bankruptcy, it was unoccupied for years, until it was rebuilt by the City of Healdsburg in the 1950s. **W**hen at the villa, you'll look out over the Alexander Valley.

In the spring, the villa itself is covered with romantic wisteria vines and is a fine place for celebrations with a pared-down style. Available for your special day are the Main Villa Building— which includes a Ballroom, Dining Room, Kitchen, and Bar—accommodating 250 seated guests, 500 standing; and the Villa Annex—which includes the Meeting Room, Commercial Kitchen, and Bar—accommodating 150 seated, 250 standing.

Villa Chanticleer

Villa Pompei
(private address)
Santa Rosa
707.545.5800
Deluxe

Villa Pompei's colonnade immediately invites your admiration and stirs your imagination. This private estate is as dramatic and romantic as any of the genteel locales in *Gone with the Wind*—only transplanted to the Wine Country.

Built atop a 350-foot hill, Villa Pompei offers sensational sights: the estate's virgin trees and well-maintained lawns, Mount St. Helena, and the Sonoma Valley. Ceremonies can be held on either the lawn or the hillside, with each spot accommodating up to 300 seated or standing guests. The estate's outdoor entertainment area, which is composed of several levels on the hillside, can be reserved in different configurations to allow guests to wander, mingle, and explore. The formal deck, on the highest level, is a great spot for dancing; the middle level is caterer-ready and features a bar. Below that is a garden, and the lowest level peers out over a pond and fountain. For as few as 50 to as many as 500 guests, this is an excellent setting for a grand outdoor wedding.

Villa Pompei

peninsula

Elizabeth F. Gamble
Garden Center
1431 Waverly Street
Palo Alto
650.329.1356
Moderate
Wheelchair accessible

This lovely spot, which features both casual and more formal gardens, is a great site for those with a passion for flowers. Do you revel in roses? The Gamble Garden Center's rose garden boasts 100 different types and is an appropriate area for a ceremony or reception for 75 seated or standing guests. Do you swoon at the sight of wisteria? There's a garden devoted to these flowers. You can even ask about combining the outdoor areas for a larger wedding.

In addition to the magical gardens, which are maintained by an on-staff horticulture professional and hundreds of volunteers, the center has attractive indoor spaces well-suited for nuptial celebrations. The main building, a Colonial/Georgian Revival home dating back to the early 1900s, provides dining and drawing rooms as well as a library; the space exhibits the antique architectural details of wainscoting, wood flooring, fireplaces, French doors, and moldings. The library overlooks a brick patio and the gardens. Another indoor wedding space at the center is the Tea House, just beyond the main house. This structure, an addition built in the late 1940s, also features French doors that open onto brick patios. The center accommodates up to 75 guests, with ceremonies taking place outdoors and receptions indoors.

Elizabeth F. Gamble Garden Center

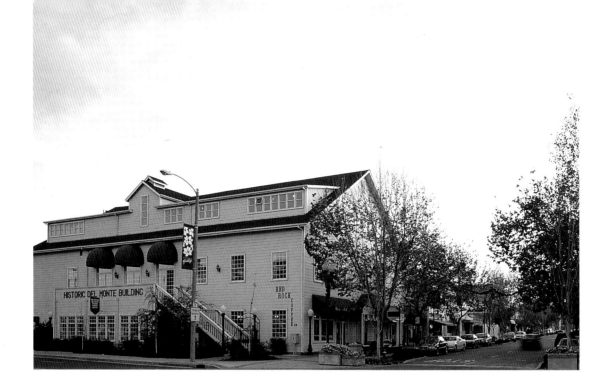

Historic Del Monte Building
100 South Murphy Avenue
Sunnyvale
408.735.7680
Moderate
In-house catering
Wheelchair accessible

The Del Monte Building, which was originally home to a seed company and is now a polished event site, was the first commercial space to be constructed in the town of Sunnyvale back in 1904. Old-time lamps shed light onto the three-story wooden structure, which is framed by swaying maple trees. Inside its formerly rough interior, visitors ascend a stairway to the building's upper levels, which were remodeled to make this setting a showplace for entertaining. The Grand Ballroom is on the second floor and accommodates ceremonies or receptions for up to 400 seated or 600 standing guests; this room's ornamental details include gleaming golden chandeliers and wainscoting of rich, dark wood. The third floor features the Del Monte Room, which accommodates ceremony or reception gatherings of 240 seated or 350 standing. This space is much more modern and sleek, with a soaring ceiling and plain walls. Some couples rent both rooms for a convenient under-one-roof affair that also allows for changes in atmosphere. Special packages are available that include food, wine, and service. Whatever option you choose, this facility offers a compelling blend of antique and contemporary.

Historic Del Monte Building

Holbrook Palmer Park
150 Watkins Avenue
Atherton
650.688.6534
Moderate
Catering can be provided
Wheelchair accessible

Located in one of the Bay Area's most elegant residential areas, Holbrook Palmer Park lends a leisurely graciousness to a wedding celebration. The tree-filled park still has the idyllic feel of the country estate it once was.

Today, relaxed privacy can be found here, perfect for a casual yet memorable affair.

Outdoors, as up to 200 guests look on, brides can make their entrance down flower-lined steps, arriving at a bower entwined with ivy and flowers, where vows are exchanged. A grand oak tree on the Jennings Pavilion patio is a natural canopy under which newlyweds can greet their guests; the patio is also a wonderful spot for an outdoor reception for up to 200. Dinners are served inside the contemporary Jennings Pavilion (for up to 130 seated or standing guests), followed by dancing. The Main House, an example of more classic architecture, is used for smaller ceremonies (up to 70 seated or standing guests); it is also a charming scene for rehearsal dinners. You can also use the park facilities for an indoor reception (150 indoor standing guests; 250 if the patio is included). Park staff are available for assistance in planning your ideal wedding situation.

Holbrook Palmer Park

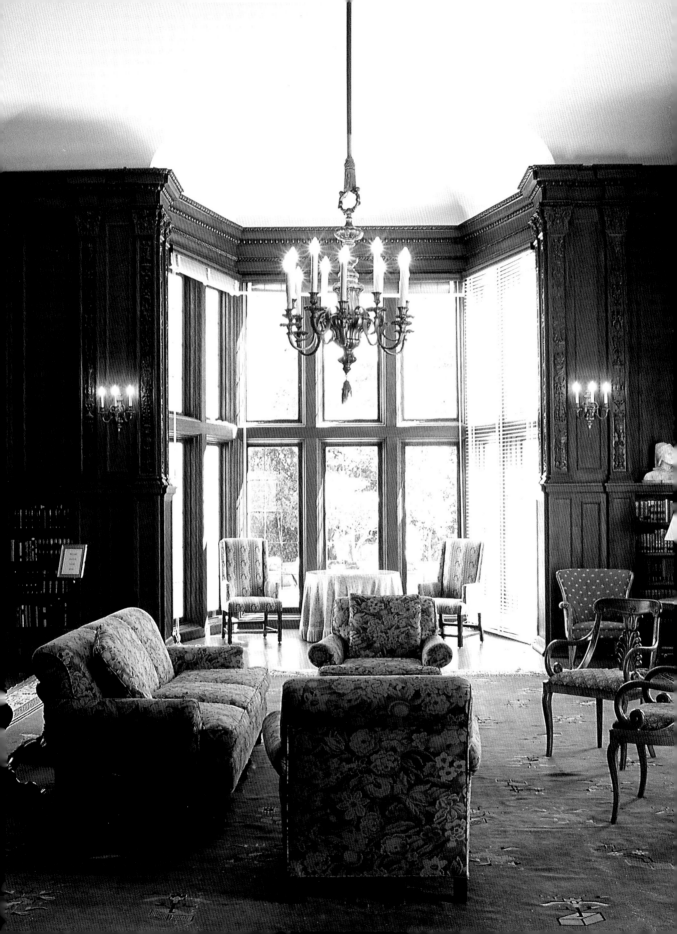

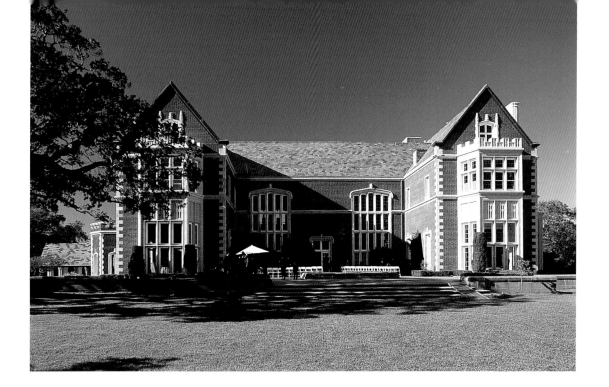

Kohl Mansion
2750 Adeline Drive
Burlingame
650.992.4668
Deluxe
Preferred caterers list
Wheelchair accessible

At the Kohl Mansion, the slogan is "Where history is still being made." The striking, 63-room, rose-colored brick Tudor mansion was built in 1912 by C. Frederick Kohl, heir to a shipping fortune, and his wife; the Kohls loved to host elegant affairs, and their legacy truly lives on.

The Great Hall, a replica of England's Tudor Hall, was constructed for lavish entertaining; it seats 150 for lunch or dinner or accommodates a standing ceremony audience of 250. The Library, with its stone fireplace, dark wood walls, and Gothic bay window, holds 100 seated, 200 standing; the Dining Room, architecturally a lighter version of the Library, has the same capacity. For slightly larger events, the Patio accommodates 250 seated, 500 standing.

For intimate gatherings, the Morning Room, which looks out over the English Rose Garden, seats 25 or holds 50 standing guests; for extra-large ceremonies and receptions, the lawn accommodates 500 seated and up to 1,000 standing. A plus: The on-staff events coordinators are helpful, enthusiastic, and experienced—and dedicated to streamlining your planning.

Kohl Mansion

Ladera Oaks
3249 Alpine Road
Portola Valley
650.854.3101
Moderate to Deluxe
Wheelchair accessible

Ceremonies (for 50 to 250 seated or standing guests) at this swim and tennis club occur outdoors on a courtyard platform with a vine-covered trellis as a backdrop. Guests stand or are seated on the grass nearby. The charming shingled clubhouse, which is covered with vines, and its environs provide a pretty site for a reception. Indoors, the Ballroom, which has hardwood floors and floor-to-ceiling windows, seats 100 to 150 guests for daytime parties and up to 180 for formal nighttime gatherings. An adjacent bar area is available for nighttime events only (after 6 P.M.). The Ballroom, when combined with the outdoor garden, can accommodate up to 350 standing guests. The flowering garden, featuring rosebushes and seasonal blooms, is surrounded with oak trees; it accommodates 200 seated guests for an outdoor celebration. (Note that use of the garden is included with Ballroom rental.) The 8-hour rental time for weddings is broken up into a precise, convenient schedule: a 2-hour setup, 4 to 5 hours for the ceremony and reception, and 1-hour cleanup.

Ladera Oaks

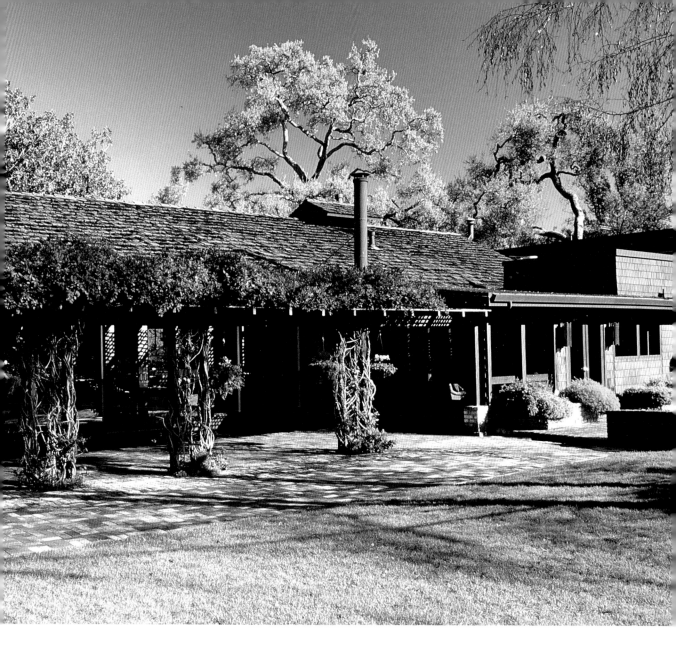

Pacific Athletic Club at
Redwood Shores
200 Redwood Shores Parkway
Redwood City
650.593.1112
Moderate
In-house catering
Wheelchair accessible

For a modern setting with plenty of dash, try the Pacific Athletic Club. Here, you'll discover a lusciously landscaped garden courtyard that's great for an outdoor ceremony for 80 seated guests. There are also ample lawns and a trellis passageway. The croquet lawn makes a refined ceremony spot, accommodating 400 seated guests.

For receptions, the Main Dining Room offers the warmth of sunlight passing through an impressive skylight and two walls that are basically giant windows; this open, airy space allows you to host 250 seated or 600 standing guests. The club's official reception area, with its intriguing walnut and cherry wood floor and unusual octagonal design, offers mirrored archways and space for a band to perform. This section of the club, which includes a lounge, accommodates up to 250 standing guests.

A small outdoor patio provides a nice dining scene for 60 seated or 200 standing guests. But if you've got a guest list of 600 seated or 1,000 standing guests and you desire an outdoor reception, the lawns can be combined to accommodate such a large gathering of family and friends.

Pacific Athletic Club at Redwood Shores

Ralston Hall
1500 Ralston Avenue
Belmont
650.593.1601
Deluxe

Ralston Hall was once the country house where William Chapman Ralston, founder of the Bank of California, entertained. San Francisco's first financial barons built many magnificent summer houses in the late 1800s, but this is the only one that still resembles its original state. Parts of the mansion recall the grandeur of France's most opulent landmarks: the 28-foot-by-61-foot ballroom brings to mind Versailles's Hall of Mirrors, and an "opera box" fashioned after those in the Paris Opera House surrounds the mansion's main staircase. In contrast, the sun parlor resembles the promenade deck of a Mississippi riverboat. In fact, the modified Italian villa has many elements of the "steamboat Gothic" mode, including sliding doors in the mansion's guest area to ensure smooth traffic between rooms; such details reminded Ralston of his experience sailing on the Mississippi prior to settling in California. This unique structure has been dubbed a National Historic Landmark as well as a California Historic Landmark; period furnishings can still be found within the mansion. **Y**ou can make Ralston Hall a personal landmark by hosting your wedding here. Outdoor ceremonies take place on the manicured front lawn; receptions tend to occur in the ballroom, dining room, parlors, and sunporch. The whole mansion can accommodate 250 seated or standing guests; fees include the services of a security hostess for the duration of your event.

Ralston Hall

Stanford Barn

700 Welch Road

Palo Alto

650.325.4339

Moderate

In-house catering

Wheelchair accessible

This distinguished, ivy-covered, three-story brick building, obviously from a bygone era, is located near Stanford University, Stanford Hospital, and Stanford Shopping Center. The Stanford Barn, built in 1888 by Leland Stanford as part of his own winery, is a sturdy structure that survived not only the 1906 earthquake but also contemporary real estate development deals; it is now considered one of the area's treasures.

Within the Barn's southwest wing is the Vintage Room, which offers 15-foot-high brick walls and stately double French doors and windows painted a dark green; it holds 200 seated or 300 standing guests. Beyond this main space, two adjoining areas provide variety: a charming, wind-protected courtyard, which serves as a pleasant outdoor scene for sharing vows, and a nearby garden (tenting can be arranged for both; these additional spots accommodate 200 seated, 500 standing guests). After your ceremony at this architecturally significant spot, you can toast to your future at a feast provided exclusively by California Cafe Catering, which is known for its innovative menus exemplifying California cuisine.

Stanford Barn

Thomas Fogarty Winery
and Vineyards
19501 Skyline Boulevard
Woodside
650.857.6772
Deluxe
Preferred caterers list
Wheelchair accessible

This winery has a superior word-of-mouth reputation, both for its wines—it produces nearly 10,000 cases of a select variety of award-winning wines annually—and as a wedding site, winning the hearts of those who have had their ceremonies here. The views from the ridge are gorgeous, and the reception areas are sophisticated and yet exceptionally comfortable. Up to 250 guests can celebrate your union at this winery, and an on-staff event coordinator will help you find caterers, florists, and musicians. An expansive, perfectly groomed lawn is an ideal outdoor ceremony spot, while receptions occur in a beautiful redwood building with parquet floors, a stone fireplace, and a semi-enclosed deck that looks out onto the Santa Clara Valley, San Francisco, San Jose, and Mount Diablo. The tasting room offers tables constructed from wine barrels and handcrafted leather chairs, and you can arrange for guests to sample the winery's chardonnays, cabernet sauvignons, gewürztraminers, and pinot noirs. Warm and tasteful, this is a first-class locale for a memorable day that captures the essence of this region.

Thomas Fogarty
Winery and Vineyards

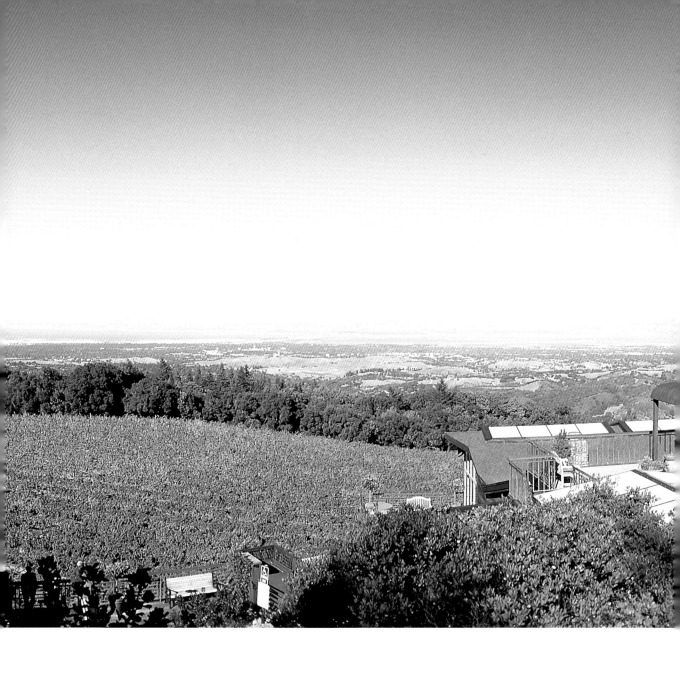

Byington Winery

Chateau la Cresta

Club Almaden

Decathlon Club

Hayes Mansion

Mirassou Champagne Cellars

Opera House

Saratoga Foothill Club

Savannah-Chanel Vineyards

Silicon Valley Capital Club

Villa Montalvo

south bay

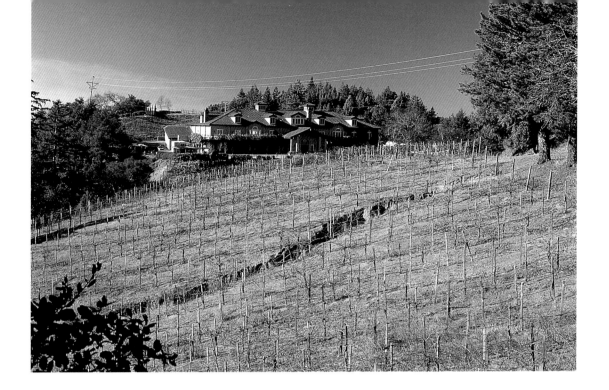

Byington Winery
21850 Bear Creek Road
Los Gatos
408.354.1111
Moderate to Deluxe
Preferred caterers list
Limited wheelchair access

At the Byington Winery, there is a slope so appropriate for tying the knot that it's nick-named "wedding hill." Up to 250 guests can witness a romance-filled outdoor cere-mony on this knoll, which also has an adorable gazebo.

Byington is a relatively new yet sophisticated winery that looks down over the redwood-covered Santa Cruz Mountains all the way to Monterey Bay. Receptions (as well as ceremonies during chillier months) take place inside the winery's large main building, an Italian-style structure covered in wisteria and grapevines. Here, celebrations occur in a private room that seats 140 and features a fireplace, hardwood floors, and a tiled terrace. The nearby Private Tasting Room and Barrel Room can be rented for larger-scale weddings. Immensely popu-lar with brides is the winery's bridal suite, a luxurious changing area in the main building that has a full-length mirror and private bath. Standard amenities include tables, chairs, glassware, and the services of an event coordinator. The facilities are generally reserved for one wedding per day.

Byington Winery

Chateau la Cresta
14831 Pierce Road
Saratoga
408.741.0763
Moderate to Deluxe
In-house catering
Limited wheelchair access

The Santa Cruz Mountains are some of the most awe-inspiring surroundings in the Bay Area, and you feel peaceful when you're among them. Located on a lofty crest in these dramatic mountains and looking down on scenic Santa Clara Valley,

Chateau la Cresta was once home to Paul Masson, whose family name is one of the best known in the California wine business. Celebrities of Masson's day—such as John Steinbeck—joined him for parties at this stunning locale.

This 580-acre property can creatively accommodate a wide variety and size of celebrations, ranging from 10 to 1,500 guests. The Chateau holds 10 to 100; the Deck, an outdoor site with views of the valley, accommodates 50 to 280; the Historic Winery, which

features a large Banquet Hall area, can hold 50 to 300; the Pool Area, an outdoor garden venue, is appropriate for intimate groups of 25 to 50. Another outdoor garden setting, the Redwood Area, accommodates 50 to 200; and the Picnic Grounds, which also overlook the valley, accommodate 200. Finally, the Concert Bowl, an amphitheater, seats 500 to 1,500. A four-star chef is on staff, and the event coordinators will ensure that the bride and groom and their families have the most pleasant of wedding days here.

Chateau la Cresta

Club Almaden
21350 Almaden Road
San Jose
408.268.7036
Moderate
In-house catering
Wheelchair accessible

Originally known as the Casa Grande, this handsome, historically significant locale was the pride of the area even when it was built back in 1854. International luminaries often stayed at this dignified and hospitable site. It hasn't changed much over the years, and it has ample areas for scenic ceremonies and receptions on the six-acre property. The club is now a restaurant and facility devoted to hosting special events.

You can arrange to say your vows at various outdoor sites (such as the ample lawn or redwood decks), which can accommodate anywhere from 100 to a whopping 2,000 guests; talk to the club to tailor a ceremony just for you. A popular option, however, is to choose one of two combinations of decks and patios, which showcase the trees and greenery that surround the building. If you should decide to rent both sets of decks and patios, you can host 450 seated or 600 standing family and friends. For receptions, the brick-walled interior can be rented in its entirety, including the bar and the Black Safe Room (named for the gigantic mining-era safe that takes up part of the room); this allows you to host 175 seated or 275 standing guests.

Club Almaden

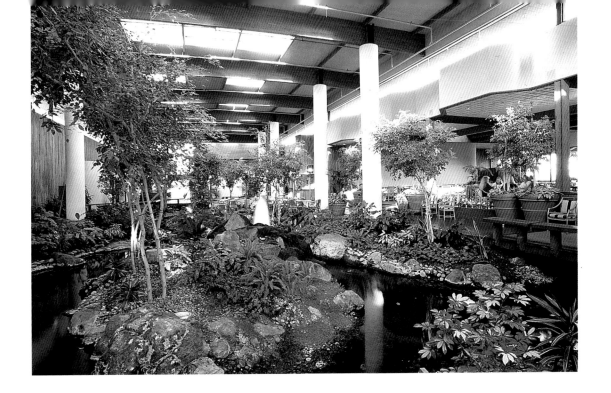

Decathlon Club
3250 Central Expressway
Santa Clara
408.736.3237
Moderate
In-house catering
Wheelchair accessible

If your wedding guest list is large yet you still want a personal ambience, consider this Silicon Valley establishment, which has developed a reputation for hosting big yet distinctive events.

The grounds feature fountains, waterfalls, and a creek and trees; indoors, the dining areas are flexible and can be arranged according to your preferences. The dining room accommodates seating for up to 600 guests and enough indoor mingling room for up to 1,500 standing guests. A hardwood dance floor is available as well. The dining room opens onto an outdoor deck, a great spot for the buffet or for more seating. Ceremonies for up to 250 guests can be held on a terrace that by day provides an Eden-like setting for sharing vows.

There are some notable standard amenities included with wedding rental of the Decathlon Club: a champagne greeting for your guests, the expertise of on-staff event coordinators, and the wedding cake. The club also specializes in international and multinational menus, and five-course dinners are a trend here.

Decathlon Club

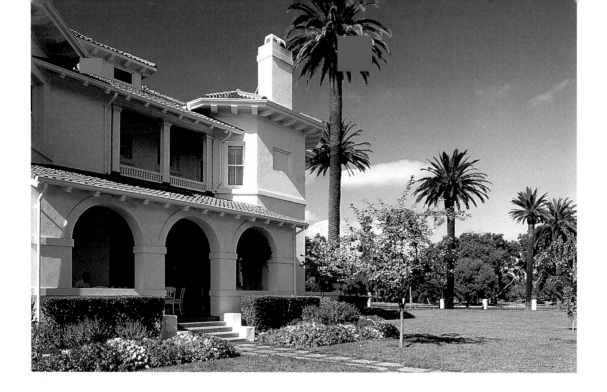

Hayes Mansion
200 Edencale Avenue
San Jose
408.226.3200
Moderate
In-house catering
Wheelchair accessible

For a South Bay wedding steeped in history and luxury, this mansion and its palm tree–lined grounds offers an illustrious past and contemporary polish. This 65-room estate was originally the home of the families who published the San Jose *Mercury News* and the San Jose *Herald*, and it was the center of the area's cultural elite until the 1950s. Now owned by the City of San Jose, the mansion and its striking four-story tower were renovated in the early 1990s to revive their former glory. Today, the commanding building and its landscaped grounds are an eye-catching venue for weddings. Brides and grooms can share vows in front of up to 1,000 guests on the expansive lawn in front of the mansion. The Mediterranean-style building is filled with Victorian details, such as bay windows and chandeliers, and smaller ceremonies and receptions can be held in either the San Jose Room or the Willow Glen Room, which seat 50 guests each, or in the larger Edenvale Room, which seats 360 guests.

Particularly festive for receptions are the formal Silver Creek Dining Room, which holds 170 seated or 205 standing guests, or the combination of the Jay Orley, Everis Anson, and Folsom Parlors, which together hold 100 seated or 150 standing revelers.

Hayes Mansion

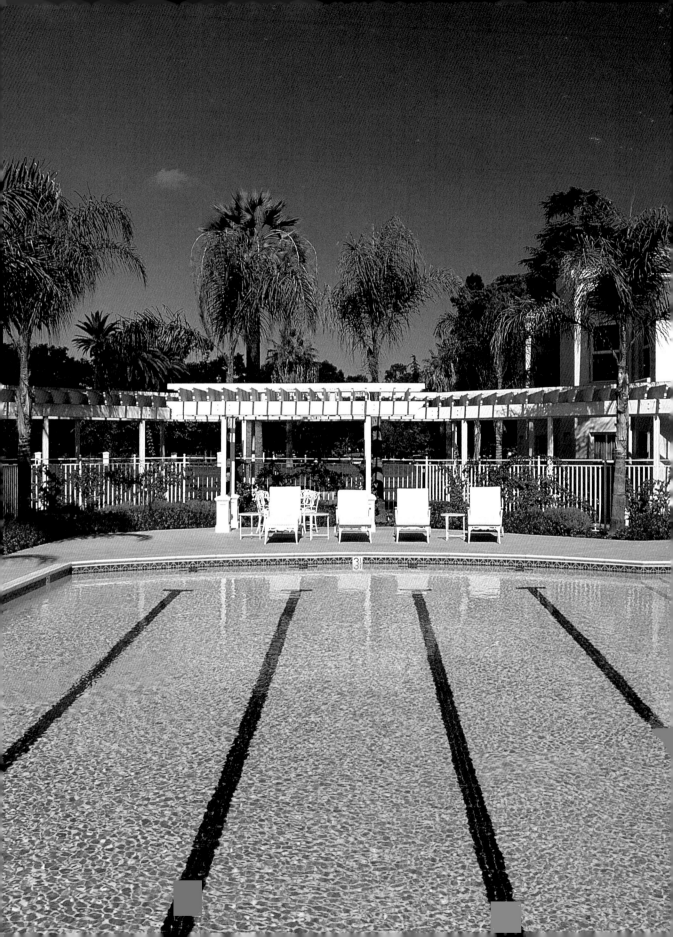

Mirassou Champagne Cellars
300 College Avenue
Los Gatos
415.395.3790
Moderate
Preferred caterers list
Wheelchair accessible

You'll be enchanted by this Old World spot in the scenic foothills of Los Gatos. Operated since 1854 by America's oldest winemaking family, Mirassou Champagne Cellars is a quiet retreat, closed in behind stone and wrought-iron gates. The historic grounds were once the site of a Jesuit seminary, and the winery itself (still in the original building) was operated by the Jesuits before Mirassou began making its award-winning wines. **A**ll weddings at the Champagne Cellars include wines carefully selected to complement your feast. (Hospitality staff is included in rental fees.) Mirassou offers lovely areas both indoors and outdoors for ceremonies and receptions. For a sun-filled occasion, exchange vows on the courtyard patio and its accompanying platforms (accommodates 150 seated, 200 standing). For an intriguing ceremony, try La Cave, the entry of the winery, which has a vaulted stone ceiling, a lovely arched doorway, and stored champagne bottles, all setting the perfect ambience for a winery wedding. Small receptions occur in the Tasting Room (accommodates 60 seated, 100 standing); midsize receptions occur in the Blanc de Noirs room (accommodates 120 seated, 150 standing).

Mirassou
Champagne Cellars

Opera House
140 West Main Street
Los Gatos
408.354.1218
Moderate to Deluxe
In-house catering or preferred
caterers list
Wheelchair accessible

Timelessly festive weddings take place at Opera House, a historic building dating back to 1904, where you'll find all the adornments of a traditionally splendid site, including a standout staircase for head-turning entrances, period light fixtures, an eye-catching mahogany bar characteristic of the turn of the century, and decorative wall and ceiling themes that hark back to the Victorian era—plus modern conveniences such as a mobile dance floor. The main Ballroom area, bright and airy thanks to a 24-foot-high ceiling with a central skylight, accommodates 320 seated or 500 standing guests. Looking down on the ballroom is a dramatic balcony on which you can host 90 seated or 200 standing guests. The Mezzanine area hosts 130 seated or 300 standing guests and includes a row of windows that let in natural light. The Opera House occupies 8,000 square feet, and the space can be arranged to your needs. If you're planning a large event, the whole building can be rented so guests can wander freely. Smaller ceremonies and parties can take place in any of the individual areas of the building. For larger gatherings, there are some excellent wedding packages available, which can include the help of an event coordinator, service, a champagne toast, a wedding cake, and valet parking.

Opera House

Saratoga Foothill Club
20399 Park Place
Saratoga
408.867.3428
Very Affordable

For a cheerful, unassuming wedding in the South Bay that blends indoor/outdoor entertaining with a nod to history—but without extra frills—the Saratoga Foothill Club possesses just the right setting. Found within a tranquil neighborhood, this architecturally notable private club was designed in the Arts and Crafts style in 1915 and is credited to Julia Morgan. The central space of the club is impressive; adjacent to a welcoming redwood foyer, the main area's ceiling is 30 feet high. You'll find a stage for your reception's entertainment as well as a pretty set of windows that let in natural light. During warmer months (generally June through October), ceremonies take place on the paved outdoor patio, which seats 150 guests among the Japanese maple trees. During this time of year, the club can accommodate 185 guests if both the indoor and outdoor spaces are used. From November through May, the temperature drops, and the capacity for the entire facility becomes 150—with optional use of the patio (the club just wants to ensure that everyone can fit comfortably inside if there's a chill).

Saratoga Foothill Club

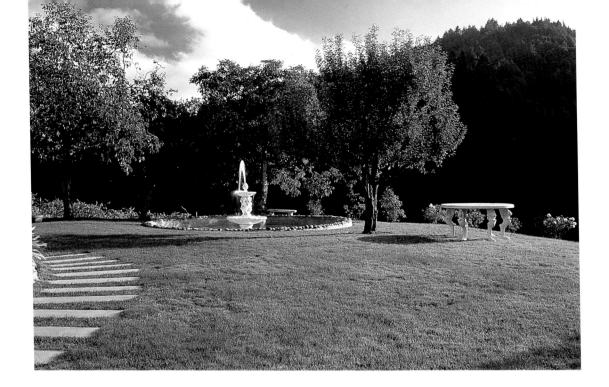

Savannah-Chanel Vineyards

23600 Congress Springs Road

Saratoga

408.741.2930

Deluxe

Preferred caterers list

Limited wheelchair access

Surrounded by valleys, peaks, redwood trees, and bountiful flowers, the stately and picturesque Savannah-Chanel Vineyards represents the finest of South Bay environments. This exquisite wedding site is found high in the Santa Cruz Mountains and offers a wide range of options to ensure an inpeccable wedding. The vineyard's Redwood Grove looks like a natural outdoor chapel and seats 100 or accommodates 250 standing guests, who will witness your vows under a canopy of redwood trees while a nearby creek provides the sweet soundtrack of flowing water. The vineyard's Patio, near a fountain, is another prime location for a ceremony (a white lattice arch can be supplied for added charm); it seats 200 to 250 guests. Receptions occur on the grounds of the vineyard's Villa de Montmartre, an enchanting Mediterranean-style home constructed in the 1920s. This lawn and garden area, which features rose bushes and is framed by fruit and willow trees, accommodates 200 to 250 seated guests at tables shaded by pristine white umbrellas. Included in rentals are wedding and wine consultations, bartenders' fees, furniture, parking for 100 cars, and parking assistance.

Savannah-Chanel Vineyards

Silicon Valley Capital Club
50 West San Fernando Street
Suite 1700
San Jose
408.971.9300
Moderate to Deluxe
In-house catering
Wheelchair accessible

High above San Jose and Silicon Valley, the Silicon Valley Capital Club, one of America's most prestigious clubs, lends a sense of downtown grandeur to a wedding celebration. Its wood pillars, oak paneling, and marble floor create a genteel atmosphere. The club's formal dining room features chandeliers as well as upholstered chairs; even the lobby, with its adjoining Buena Vista bar, is an elegant setting.

Indoor seated receptions work well for up to 180 guests. The club has a roomy terrace with breathtaking views, and it's a spectacular site for a ceremony; the terrace holds 150 seated or standing guests. Ceremonies can also take place in the club's indoor lounge (150 seated guests). If both indoor and outdoor space is used for your reception, the club can accommodate up to 250 seated guests or up to 400 standing guests. If your guest list is smaller, intimate ceremonies or receptions can be held in one of the club's private conference rooms. The South Bay's balmy climate and this location's dazzling views make evening weddings at the club an excellent choice.

Silicon Valley Capital Club

Villa Montalvo

15400 Montalvo Road

Saratoga

408.741.3421

Deluxe

List of caterers can
be provided

Wheelchair accessible

A historic estate for the arts, Villa Montalvo is known both for hosting artists-in-residence from around the globe and for its concert series. This classic Mediterranean villa was built in 1912 by James Duval Phelan, a three-term progressive mayor of San Francisco and the first U.S. senator from California elected by popular vote. The villa, located some 800 feet high in the breathtaking hills of the South Bay, was in Phelan's day a center of artistic, social, and political events (some of Phelan's favorite guests included Jack London and Douglas Fairbanks). This is an exquisite wedding site as well. Garden ceremonies take place amid lavender, colorful roses, and wisteria in the Oval Garden, which seats up to 200 guests—an intimate locale within the estate's 175-acre arboretum. Wedding receptions take place on the villa's main floor and surrounding areas. The front veranda holds 200 seated or standing guests for outdoor celebrations; indoors, the main gallery, adjoining the villa's solarium, library, and dining room, accommodates 175 seated or 200 standing guests. You can request a champagne toast in the lovely Spanish courtyard, complete with fountain, as the perfect segue from ceremony to reception.

Villa Montalvo

Index